POSTCARD HISTORY SERIES

# The
# Blue Ridge Parkway

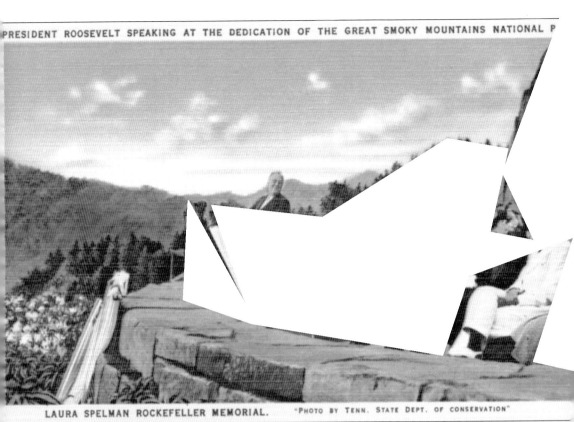

PRESIDENT ROOSEVELT SPEAKING AT THE DEDICATION OF THE GREAT SMOKY MOUNTAINS NATIONAL P

LAURA SPELMAN ROCKEFELLER MEMORIAL.    "PHOTO BY TENN. STATE DEPT. OF CONSERVATION"

**FRANKLIN ROOSEVELT.** On September 2, 1940, Franklin D. Roosevelt and several thousand visitors dedicated the National Park System at the top of Newfound Gap in the Laura Spelman Rockefeller Memorial. This was the fruition of dreams for President Roosevelt and several other forward-thinking environmentalists. Decked out in red, white, and blue, the ceremony highlighted the enthusiasm of the American public to preserve such a great heritage. (Courtesy of Asheville Post Card Company.)

*Front cover:* **BLOWING ROCK, NORTH CAROLINA WITH GRANDFATHER MOUNTAIN IN THE DISTANCE.** *Ripley's Believe it or Not* states, "The Blowing Rock is the only place in the world where it snows upside down." Blowing Rock, North Carolina, is the place to escape from it all—cooler temperatures, exquisite landscapes, a storybook village, shopping, hiking, skiing, arts, festivals, attractions, and so much more. (Courtesy of Asheville Post Card Company.)

*Back Cover:* **MABRY MILL.** Mabry Mill on the Blue Ridge Parkway near Meadows of Dan is reminiscent of days gone by. Water rushes down the flume and splashes over the massive wheel, which grinds corn meal. This mill is typical of the ingenuity of the pioneer people that settled this area. (Photographed and distributed by the Camera Artist of Farmville, Virginia.)

POSTCARD HISTORY SERIES

# The
# Blue Ridge Parkway

Karen J. Hall
and the
Friends of the Blue Ridge Parkway

ARCADIA
PUBLISHING

Copyright © 2005 by Karen J. Hall and the FRIENDS of the Blue Ridge Parkway
ISBN 978-0-7385-4224-9

Published by Arcadia Publishing
Charleston SC, Chicago IL, Portsmouth NH, San Francisco CA

Printed in the United States of America

Library of Congress Catalog Card Number: 2005933223

For all general information contact Arcadia Publishing at:
Telephone 843-853-2070
Fax 843-853-0044
E-mail sales@arcadiapublishing.com
For customer service and orders:
Toll-Free 1-888-313-2665

Visit us on the Internet at www.arcadiapublishing.com

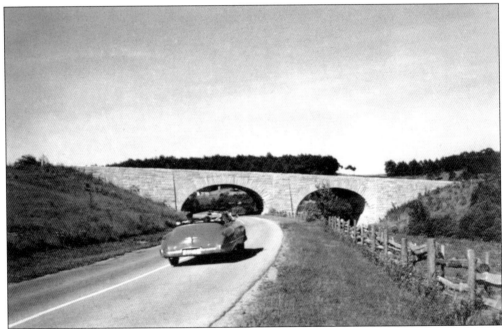

GALAX OVERPASS AND EXIT ON THE BLUE RIDGE PARKWAY. This scene is typical of the southwestern Virginia countryside. Six miles south of Galax, Virginia, where Highway 89 and the Blue Ridge Parkway cross, are two beautiful arches that were created by the CCC workers during the construction of the parkway. At one time, this was one of two original overpasses on the parkway (c. 1951). (Courtesy of Roanoke Photo Finishing Company.)

# CONTENTS

| | |
|---|---:|
| Acknowledgments | 6 |
| Introduction by FRIENDS of the Blue Ridge Parkway | 7 |
| A Note on the History of Postcards | 9 |
| 1. The Blue Ridge Parkway, Virginia | 11 |
| 2. The Blue Ridge Parkway, North Carolina | 37 |
| 3. Shenandoah National Park and Skyline Drive | 63 |
| 4. The Great Smoky Mountains | 75 |
| 5. The Eastern Cherokee Nation | 107 |
| 6. Gatlinburg and Pigeon Forge, Tennessee | 119 |
| Bibliography | 126 |
| Index | 127 |

# Acknowledgments

Postcard collectors enjoy talking about their postcard collections. They are called "deltiologists." I am very privileged to have met many deltiologists in the process of compiling this book, and I greatly appreciate all of the time that they shared with me.

In addition to the sources listed in the bibliography, much of this information came from individuals with connections to the parkway. Appreciation is extended to each of the following individuals and organizations for taking the time to enlighten me about the facts of the Blue Ridge Parkway, the Shenandoah Valley, Skyline Drive, the Cherokee Indian Reservation, and the Great Smoky Mountains.

Waddell Waters deserves a special thank you for editing and giving me hints on how to make this production better than the last. His encouragement is very refreshing.

Postcard collectors have educated me on the production of postcards and shared their special knowledge. I would like to say thank you to Steve Messengill with the North Carolina Archives for taking the time to show me the collection in the archives.

A special thanks to Dean Stone for allowing me to use his beautiful winter scenes from the Great Smoky Mountains. They are so beautiful that this project would not have been complete without them.

My new friend Susan Mills, executive director of the FRIENDS of the Blue Ridge Parkway, has been a joy to work with. She has offered wonderful encouragement and excitement to the project.

My family deserves the greatest thanks of all. They supported me every step of the way and helped me search out local flea markets for great little treasures. My husband, Clint, helped me hunt at antique shops, flea markets, and all the venues in the Smoky Mountains that I could find. My daughter, Kate, helped me hunt at flea markets and on the Web. They both tolerated my new hobby, collecting postcards.

# Introduction

*The Blue Ridge Parkway, America's living rural life museum, is becoming an endangered species.*
—Dr. Harley Jolley, historian and national authority
on the Blue Ridge Parkway

The Blue Ridge Parkway is a special place—a 469-mile road that climbs the ridge lines and peaks of the Appalachian Mountains, every year carrying 23.5 million visitors between Shenandoah National Park and the Great Smoky Mountains. It is one of the most visited and loved parks in the country, and for that very reason, Dr. Harley Jolley has termed it an "endangered species." Residential and commercial growth, pollution, and non-native predatory insects are taking their toll on the parkway's views, trees, and wildlife. It is not going unnoticed.

As of August 2005, the Blue Ridge Parkway's 501(c)(3) nonprofit membership organization, FRIENDS of the Blue Ridge Parkway, Inc., has topped 7,000 members. These individuals recognize the historic and natural value of the Blue Ridge Parkway—and the threats to its survival.

In partnership with the National Park Service as well as other organizations, businesses, and agencies, the staff and membership of FRIENDS have made it their mission to protect the parkway and raise public awareness of this national treasure so that future generations will continue to experience this unique journey.

That experience can be a grand one—469 miles of views that stretch for miles through the mists and clear skies of the East.

It can be an intimate experience—469 miles of special moments: moments of peace, moments of learning, moments of rejuvenation, moments we are all seeking in a world irrevocably changed since September 11, 2001.

The parkway is unusual among national parks in that it is linear, passing through two states (Virginia and North Carolina) and 29 counties, touching human and natural communities along the way. The parkway, called "America's Most Scenic Drive," is within one day's drive of more than half of the population of the United States.

The parkway is a rich tapestry, weaving natural beauty and history with human cultural heritage. It is America's living rural-life museum, where basket-weavers, traditional Appalachian musicians, blacksmiths, and quilters bring the past to the present.

Historic sites such as gristmills, bridges, and one-room schoolhouses exist along the parkway, and over 350 miles of trails crisscross its length, connecting with the Appalachian Trail and even older pathways that wind through forests of hardwood, evergreen, and the endangered hemlock.

All special places of great beauty are affected by time, and the Blue Ridge Parkway is no exception. Residential and commercial development is compromising its views and wildlife habitats; pollution is fogging its clear air, and predators are destroying its trees.

Recognizing these threats, FRIENDS has pledged to help preserve, protect, and promote the outstanding natural beauty, ecological vitality, and cultural distinctiveness of the Blue Ridge Parkway and its surrounding scenic landscape, preserving this national treasure for future generations.

Founded in 1989 by the Blue Ridge Parkway superintendent, FRIENDS was organized to provide a link between parkway visitors and the parkway experience. It was believed that the organization and its members could be a catalyst for ensuring the preservation, conservation, and enhancement of the parkway, which is not only a scenic asset but an economic one, bringing millions of visitors and tourists to Virginia and North Carolina every year.

A growing membership base reflects FRIENDS' vitality and grassroots success. Many of the organization's key projects enlist the labor and energy, as well as the financial support, of members to accomplish its goals.

Here are our key projects:

**SAVE PARKWAY VIEWS.** Both FRIENDS and the Park Service feel that the parkway's greatest threat today is encroaching development that impacts the visual experience. The work of FRIENDS includes raising money, soliciting donations, and involving community volunteers in planting trees along the parkway to buffer undesirable views. These viewsheds are landscaped to restore visitors' visual experiences along the parkway, to reestablish wildlife habitats along the parkway corridor, and to rebuild an ecological buffer against development.

As the only authorized agency to restore parkway views, FRIENDS has identified over 50 views along the 469-mile parkway that need immediate attention. Each view restoration has a price tag of over $20,000.

**THE VOLUNTEERS-IN-PARKS (VIP) PROGRAM: ENRICHING OUR HERITAGE.** This is a vital part of the National Park System. In the fiscal year 2004, 140,000 volunteers donated 5 million hours to your national parks at a value of $85.9 million.

As corporate giving and federal funding decrease, National Park Service staff and resources become more limited. Volunteers play a critical role in filling the gaps by providing innumerable services, including assisting visitors in welcome centers, maintaining trails, staffing campgrounds, and providing historical interpretation and cultural demonstrations.

Enriching our Heritage Program helps the bog turtle, a federal endangered species that lives along the wetlands adjacent to the Blue Ridge Parkway. FRIENDS provide transmitters that track the turtles, allowing biologists to study them.

**TRAILS FOREVER PROGRAM.** This program seeks to improve the quality of the Blue Ridge Parkway trails, enhance the experiences of the park user, and engage the corridor communities in sustaining the park's trail system forever. FRIENDS works with the Park Service to expand and build a first-class trail system, but we can only do this with your help.

Community-based action is at the heart of FRIENDS' volunteer-based organization. Adopt-A-Trail and other projects like it empower community-based groups along the Blue Ridge Parkway corridor to collaborate in preserving a treasure in their own backyards. The hiking experience deepens public awareness of the grandeur and fragility of the Blue Ridge Parkway.

**PRESERVE THE HEMLOCKS.** Help us defeat the wooly adelgids that threaten our unique and spectacular hemlock forest. The hemlock wooly adelgid is native to Asia where it is not a problem to local hemlocks. In 1950, it was introduced to the eastern part of the United States, where it does not have natural enemies in our environment—and is therefore a deadly threat.

FRIENDS is a vital and growing organization, working in partnership with the National Park Service and involving communities, individuals, other nonprofit organizations, and businesses. Its members and supporters come from every state in the nation as well as from overseas.

In a time when the world is becoming increasingly uncertain, when our view of the future is less than clear, the Blue Ridge Parkway stretches along mountains that are ageless. These mountains will remain healthy, beautiful, serene retreats from the busy world as long as we continue to protect them from that same world.

For membership information or donations contact:
FRIENDS of the Blue Ridge Parkway, Inc.
Post Office Box 20986
Roanoke, Virginia 24018
1-800-288-PARK (7275)
www.BlueRidgeFriends.org

—Susan Mills
Executive Director

# A Note on the History of Postcards

This book has been written to share the wonderful postcards of bygone eras, not as a tour guide to the parkway. If you discover a new destination in the process, I am sure you will enjoy the journey there.

Postcards say a lot about the place, time, and people that send the messages inscribed on the back of them. The intentions of Images of America: *The Blue Ridge Parkway* is to take you, the reader, on a stroll down memory lane and to inspire you to want to preserve the beautiful views that have made the Blue Ridge Parkway and other scenic byways famous.

One of the first known uses of the American postcard began in 1862 when William Henry Jackson used to hand draw pictures of the Civil War battlefields. He used these to correspond with his family. During 1873, the federal government began producing postal cards that the post office sold with stamps preprinted. One side contained the address, and the other side contained the message. These cards were used until 1898, known as the "Pioneer era" of postcards.

Most collections today of the Pioneer-era postcards include those placed on sale at the Colombian Exposition in Chicago, Illinois, on May 1, 1893. These contained illustrations on government printed postal cards and on privately printed cards. The government printed cards had the 1¢ stamp printed on the address side. The privately printed souvenir cards had a place for the 2¢ adhesive stamp. Writing was not permitted on the address side of the card.

In 1898, the "Private Mailing Card era" (PMC) began. Private printers were permitted on May 19, 1898, to print and sell cards that bore the PMC inscription. The sender would attach stamps to the card. They were the same price as the government postal cards. The majority of PMCs were "greetings from" or souvenir cards. Here again, only one side was for the address and the other for the message. Often the printer would leave a wider border around the scenic side for the writer to send a message.

In 1901, Congress allowed the use of post card or postcard (one or two words) to replace the "Private Mailing Card" terminology. Usually on one side, the card had a picture with a small amount of room to write. The reverse side was still reserved for the address. The "Undivided Back era" of the postcard lasted until March 1907. At this time, private citizens began taking black-and-white photographs and had them printed on paper with postcard backs.

On March 1, 1907, the "Golden era" or the "Divided Back era" of postcards began. On this date, people were allowed to mail divided-back cards. This era lasted until 1915. During this time, the message and address could be written on the back side allowing the front side to contain only the image. A new hobby of postcard sending and collecting began during this era.

Up to this point, most postcards were printed in Germany. German printers were far ahead of the American printers in the lithographic process. With the onset of World War I, Americans had to print postcards. After the war, the American printers had fully mastered the skill of printing postcards. The American postcard was never dependent on foreign printers again.

From World War I until 1930, most postcards were printed with a white border surrounding the image. This saved ink and reduced the image size. This era is known as the "White Border era" or "Blue Sky era," lasting from 1919 to 1930. The reason it is called the Blue Sky era is that printers always added blue sky to the scene. High labor cost, inexperience, and public taste

effected production of poor quality cards. High competition in a thinning market caused many publishers to go out of business during this time period.

Another new era began in 1930. With the new printing process giving cards a textured or linen-like feel, the "Linen era" began. This allowed the use of bright printing dyes and allowed for a greater production, thus lowering the price of the postcards. Many roadside shops stocked and sold these cards. This era lasted from 1930 until the late 1950s. During this time period, the National Park System was under construction. Photographers and artists alike began to capture the scenic highways and byways. The firm of Curt Teich flourished with its line of linen postcards. Linen cards recorded many historical events.

The next generation of postcards began in 1939. It was known as the "Chrome era" and captured many of the American scenes with the camera. Union Oil Company launched this era in their western service stations. Mike Roberts was a pioneer with his "WESCO" cards soon after World War II.

New photographic techniques and printing processes allowed for real photographs to be used as postcards. In the beginning of this era, black-and-white photography dominated the field. They were called "Real Photo Postcards" (RPPC). Today most postcards are printed in color and can be found in almost every motel or vacation spot on a postcard rack. With the invention of the telephone and e-mail, there are quicker ways to communicate with someone. But as long as postcards are produced, they will continue to record the scenes of the Blue Ridge Parkway and other scenic byways.

# *One*

# BLUE RIDGE PARKWAY, VIRGINIA

> *Man's dreams and visions are frequently years in advance of his accomplishments.*
> —Harley Jolley, *The Blue Ridge Parkway*

The "Scenic," as locals call the Blue Ridge Parkway, is the all-American highway with beautiful views. It runs a total of 469 miles through the beautiful Blue Ridge Mountains, a major mountain chain that is part of the Appalachian Mountains. It has become a museum of the American countryside, preserving old homesteads, rail fences, and traces of early industries such as logging railways and an old canal.

In this chapter, the reader will see how the construction of the parkway helped the economy of small towns dotted along the way in Virginia. The Blue Ridge Parkway is the result of a series of public works projects that provided a boost to the travel and tourism industry and helped the Appalachian region climb out of poverty during the Great Depression. Work began on the Virginia segment in February 1936. On June 30, 1936, Congress officially authorized the establishment of the "Blue Ridge Parkway." It was placed under the jurisdiction of the National Park Service.

The most famous New Deal program was the Civilian Conservation Corps. CCC camps were built on or near the parkway for convenience. Their crews built roads, bridges, graded slopes; improved fields and forest along the roadsides; and performed other difficult tasks. They lived in camps of about 250 men and were trained and organized by the army.

Two basic types of overlooks were constructed. The primary type offered a panoramic view of mountains and valleys. The landscape painting type of overlook features an interesting cultural or natural resource often explained with a gunboard sign or interpretive easel.

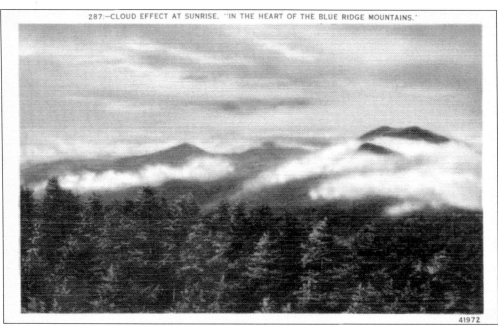

**CLOUD EFFECT AT SUNRISE, "IN THE HEART OF THE BLUE RIDGE MOUNTAINS."** As the sun warms up the early morning hours, fog and clouds begin to slowly disappear above the skyline along the Blue Ridge Mountains. The moisture regeneration creates the daily showers in the summer along the mountaintops. Combined with the natural gases that the plants emit, this creates the famous blue fog. (Courtesy of Asheville Post Card Company.)

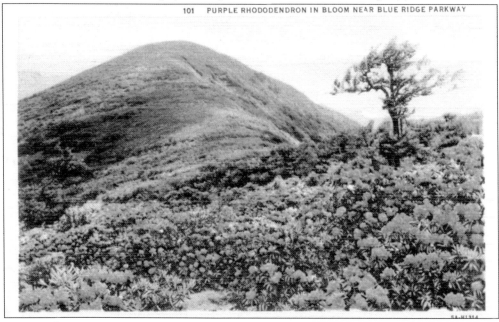

**PURPLE RHODODENDRON IN BLOOM NEAR THE BLUE RIDGE PARKWAY.** Rhododendron are native to the Blue Ridge Mountains. They come in many varieties varying in colors from pink and purple to orange. In the early spring, one can drive the Scenic and see many beautiful bushes in bloom. (Courtesy of Curt Teich and Company, Inc.)

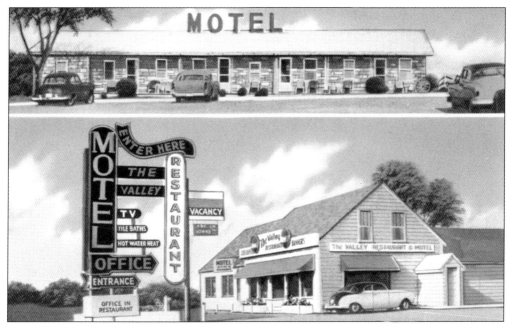

**THE VALLEY MOTEL AND RESTAURANT, FINCASTLE, VIRGINIA.** The Valley Motel was pictured in this linen-type postcard. Located in Botetourt County, Virginia, this motel boasted Beautyrest mattresses, hot water, tile baths in every room, wall-to-wall carpet, and television. As motor cars filled the highways, small private motels began to dot the countryside to provide respite to the weary traveler. (Courtesy of Chas. J. White.)

**IN OLD VIRGINIA.** Poetry was very popular in the early 20th century, as seen in this linen-era postcard. Virginians are known to have a very special fondness for their home state, and they have expressed it in many different types of art. (Courtesy of J. P. Bell Company.)

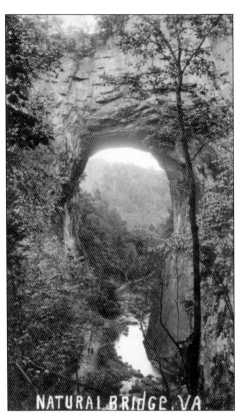

**NATURAL BRIDGE, VIRGINIA.** One of the natural wonders of the world, Natural Bridge spans the test of time. No other structures like it exist. It was created by running water millions of years ago, although it is shown here c. 1935 in black and white.

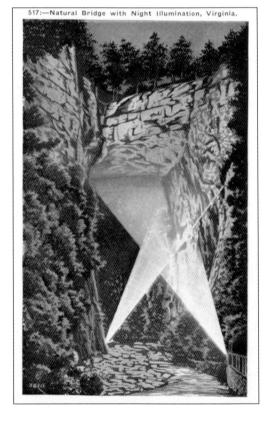

**NATURAL BRIDGE WITH NIGHT ILLUMINATION, VIRGINIA.** On May 22, 1927, then-president Calvin Coolidge pressed the button that inaugurated the night illumination of Natural Bridge. Phineas Stevens, celebrated lighting engineer, had designed and installed an impressive system of lighting that transforms the bridge and glen at night into a marvel of living stone. (Courtesy of Asheville Post Card Company.)

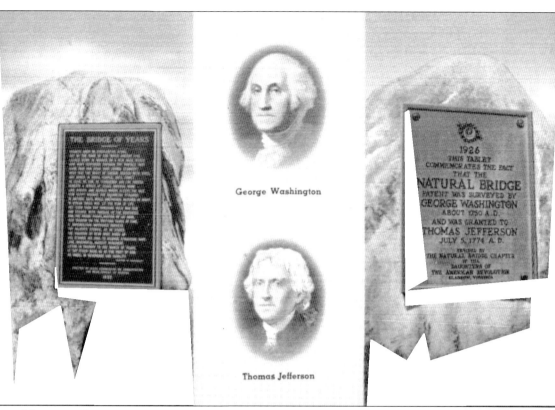

**NATURAL BRIDGE PLAQUES TO GEORGE WASHINGTON AND THOMAS JEFFERSON.** Erected in 1932, these plaques commemorate the involvement of the two most famous Virginian-born presidents, George Washington and Thomas Jefferson. George Washington surveyed Natural Bridge in 1750 for King George III of England under the supervision of Lord Halifax. Another famous former president and naturalist, Thomas Jefferson, acquired the Natural Bridge and 157 acres surrounding the bridge from King George III for 20 shillings on July 5, 1774. (Courtesy of Natural Bridge of Virginia, Inc.)

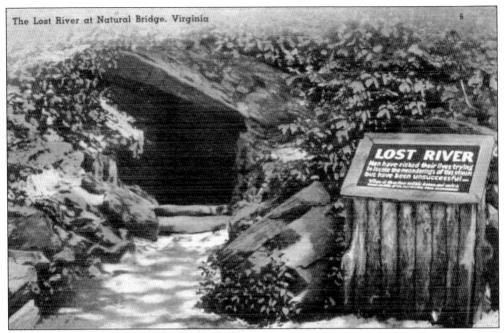

**THE LOST RIVER.** Located at Natural Bridge, the Lost River is visible through a low arch in the side of the mountain, its sparkling waters flow from an unseen cavern above to one below the creek. (Courtesy of Natural Bridge of Virginia, Inc.)

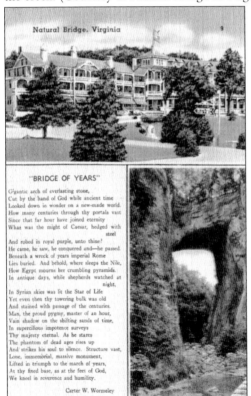

**MULTI-VIEW OF NATURAL BRIDGE AND HOTEL.** No other structures exist like Natural Bridge. It is one of the natural wonders of the world. It is 55 feet higher than Niagara Falls. The hotel is open year-round. This wooden structure burned in 1963 and was replaced in September 1964 by a brick structure that is now the entrance building. (Courtesy of Natural Bridge of Virginia, Inc.)

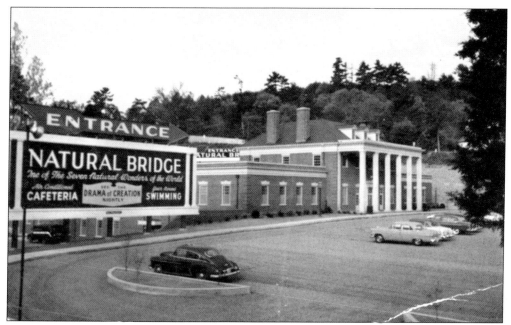

ROCKBRIDGE CENTER, NATURAL BRIDGE, VIRGINIA. The Rockbridge Center is the main entrance to the Natural Bridge, the cafeteria, gift shop, swimming pool, and recreation rooms as seen in this chrome-era postcard. Today the Rockbridge Center houses a toy museum, gift shop, and snack bar. (Courtesy of Herbert Lanks.)

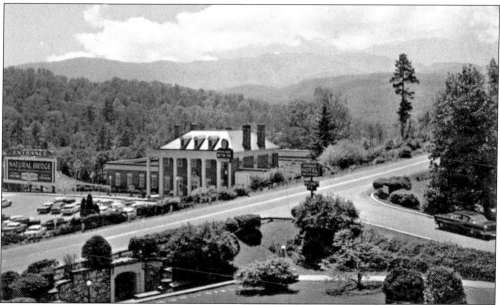

THE NATURAL BRIDGE ENTRANCE BUILDING, SHOWING THE BLUE RIDGE MOUNTAINS IN THE BACKGROUND. During the 18th and 19th centuries, Natural Bridge became a well-loved resort in the Shenandoah Valley. Visitors from all over the world would take day trips from Natural Bridge on horse-drawn carriages to explore the countryside. With the ever-increasing number of visitors, the resort created a wonderful entrance building to accommodate the visitor as can be seen in this chrome-era linen postcard c. 1950. (Courtesy of Natural Bridge of Virginia, Inc.)

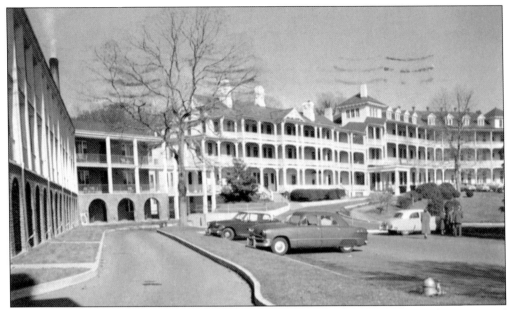

MOTOR INN AND HOTEL, NATURAL BRIDGE, VIRGINIA. In 1828, Thomas Jefferson erected the first cottage at Natural Bridge. He owned this property and would bring his friends and hunting buddies to explore the bridge and caves. Once he passed away, his estate sold this property in 1880. Now, the hotel is privately owned and has 200 rooms. This structure burned in 1963 and was replaced with the brick entrance building and hotel in September 1964. (Courtesy of Natural Bridge of Virginia, Inc.)

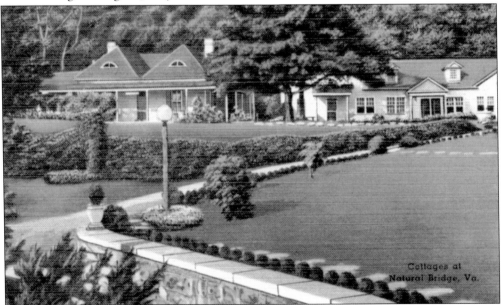

COTTAGES AT NATURAL BRIDGE. Natural Bridge has accommodated travelers since 1833. The first hotel, the Jefferson Cottage, was built in 1828 by Jefferson for his personal guests. It was a two-room log cabin. Jefferson's heirs sold the property in 1833 to a new owner that erected the Forest Inn to accommodate the increasing number of people. (Courtesy of Natural Bridge of Virginia, Inc.)

**SHARP TOP.** One of the Peaks of Otter, Sharp Top stands 3,875 feet high. This peak borders the Blue Ridge Parkway in southwest Virginia near Bedford. The drive seen in the foreground connects with good roads leading from the areas such as Charlottesville, Lynchburg, Lexington, Buena Vista, Harrisonburg, Staunton, Waynesboro, Luray, Buchanan, Clifton Forge, Covington, and Roanoke and extends farther into southwest Virginia. This is an excellent example of a chrome-era card. (Courtesy of Roanoke Photo Finishing Company.)

**PEAKS OF OTTER.** Peaks of Otter, located at milepost 85.9, faces Sharp Top mountain. Animals such as bobcat, fox, beaver, skunk, and otter are carefully preserved for the study of animal ecology. Interpretive panels and audiovisual aids help the visitor understand the delicate relationship between animals and plants in the natural history of the parkway. Visitors could take a bus to the top of Peaks of Otter at one time and view the wonderful panorama considered by many as one of the national scenic points of interest. There are three theories as to how the Peaks of Otter were named. First, the name may have come from an American Indian word, ottari, meaning high peaks. Second, they may have been named after Otter Creek. Third, Scottish settlers may have named the peaks after a settler, Ben Otter. A mountain in their Scottish homeland resembles Sharp Top. (Courtesy of Roanoke Photo Finishing Company.)

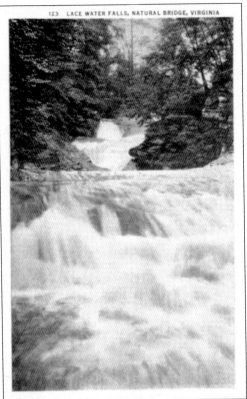

**LACE FALLS, NATURAL BRIDGE, VIRGINIA.** At the end of the Natural Bridge Glen lie the breathtaking Lace Falls. They have a drop of 50 feet. The falls are located on an easy two-mile-round hiking trip from the Natural Bridge on Cedar Creek. (Courtesy of Marken and Bielfeld, Inc.)

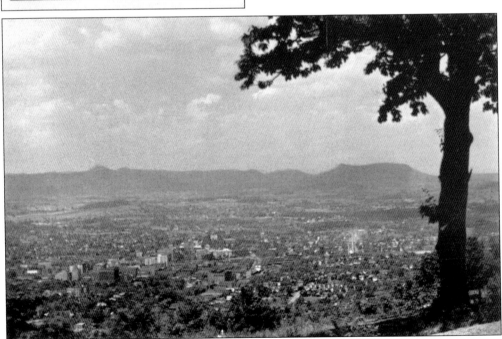

**ROANOKE, VIRGINIA.** Roanoke is the third largest city in Virginia, situated in a bowl between the Blue Ridge Mountains and the Allegheny Mountains. Mill Mountain, a city park in the heart of the city, rises 1,000 feet above the city proper. (Courtesy of Roanoke Photo Finishing Company.)

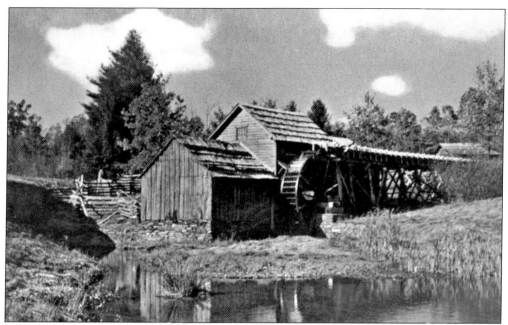

**MABRY MILL ON THE BLUE RIDGE PARKWAY, MEADOWS OF DAN, VIRGINIA.** Edwin Boston Mabry (1867–1936) built his water-powered mill in Meadows of Dan, Virginia, long before the Blue Ridge Parkway was established. By 1905, it was in operation as a gristmill. Now it is the most-photographed mill in Virginia, and it is run by the National Park Service (milepost 176.2) and has several hundred thousand visitors each year. (Courtesy of National Park Concessions.)

**MABRY MILL LUNCH AND CRAFT SHOP.** Corn and buckwheat cakes made from Mabry Mill products are served to parkway visitors in this quaint lunch and craft shop. During opening hours, one can pull up in the parking lot and smell the delicious Virginia country ham and buckwheat cakes cooking on the grill. Native mountain crafts are also available in the craft shop. (Courtesy of National Park Concessions.)

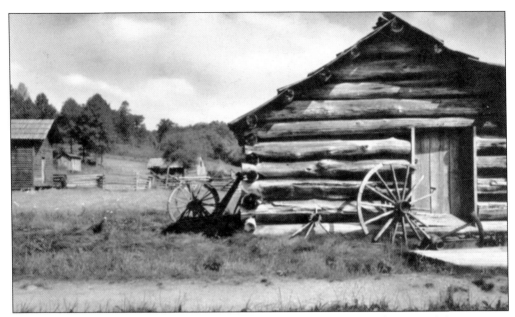

BLACKSMITH SHOP AT MABRY MILL. This pioneer settlement in southern Virginia represents a phase of culture rapidly passing from the American scene. Numerous tools indicate the craftsmanship typical of the Blue Ridge settlers in southwestern Virginia. Other interpretive media found at this site include the Matthews Cabin, whiskey still, and a sorghum mill. On Sunday afternoons, bluegrass music can be heard played by local musicians. (Courtesy of National Park Concessions.)

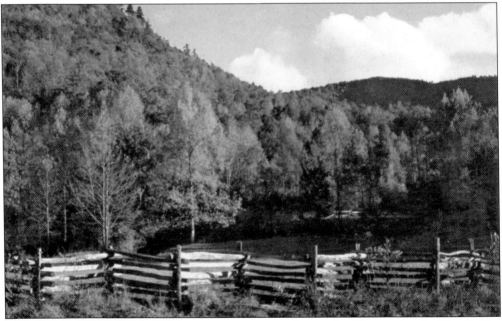

FALL IN THE BLUE RIDGE MOUNTAINS. Each year during the fall months, the Blue Ridge Mountains give a spectacular show of multiple colors. The leaves turn vibrant reds, yellows, and oranges. Visitors the world over drive the Blue Ridge Parkway to view the show. (Courtesy of Asheville Post Card Company.)

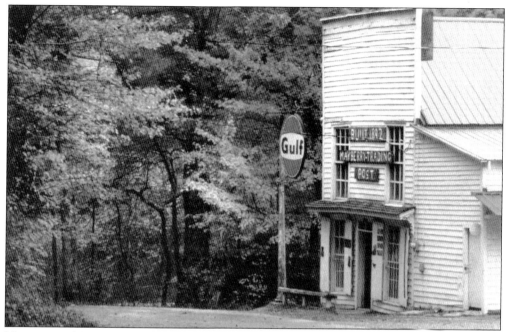

**MAYBERRY TRADING POST, BETWEEN MILEPOST 180–181.** Built in 1892, the Mayberry Trading Post offered general merchandise to the locals up until the 1970s. It was formerly the Mayberry, Virginia, Post Office building. Many RC Colas and Moonpies were sold on hot summer days at the Mayberry Trading Post. (Courtesy of Dell Yeatts.)

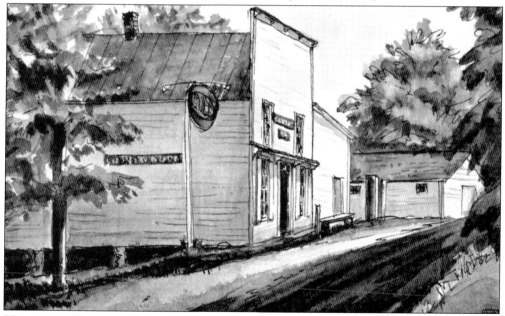

**MAYBERRY TRADING POST DRAWING.** From this sketch of the trading post, it is obvious that this location is timeless because it looks today as it did over 100 years ago—inviting and welcoming. The visitor is greeted with warm smiles and hellos (milepost 180–181). The shelves are loaded with homemade jams, jellies, apple butter, pickles, fried apple pies that make your mouth water, and other country crafts. (Courtesy of Dell Yeatts.)

**COUNTRY ROAD.** Connected to the Blue Ridge Parkway in Carroll County, Floyd County, and other counties of Virginia are quiet country roads like the one in this vintage linen-era card. Sharp hairpin curves are a signature of mountain roads. Some people call them "kiss your butt" curves because by the time the front end of the car is around the curve, you are so turned back you could "kiss your butt." (Courtesy of Asheville Post Card Company.)

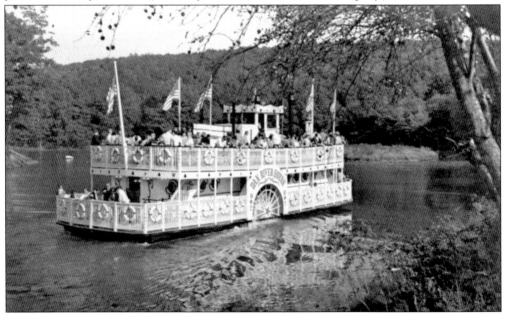

**DAN RIVER QUEEN, STUART, VIRGINIA.** Just a short distance from Mabry Mill, *Dan River Queen* was moored at Cockram's Mill and the Good Luck Country Store between Stuart, Virginia, and the Blue Ridge Parkway on U.S. Highway 58. The authentic, old, side-paddlewheel riverboat offered daily cruises to visitors. (Courtesy of Asheville Post Card Company.)

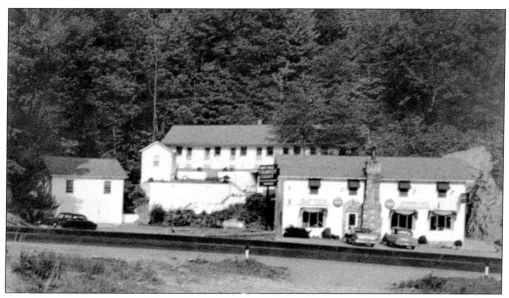

**BLUE RIDGE COURT AND RESTAURANT, FANCY GAP, VIRGINIA.** Located on U.S. Highway 52, just two miles south of the Fancy Gap Blue Ridge Parkway exit, the Blue Ridge Court was a favorite to many visitors with views of the North Carolina foothills. Famous for country hams and western steaks, the Blue Ridge Restaurant served many travelers. A bubbling mountain stream ran beside the motel and restaurant through a huge water wheel. C. D. Phillips and his son built this establishment in the early days of the Blue Ridge Parkway. It closed in the 1950s when a newer motel was built at the Fancy Gap exit. (Courtesy of Fred W. Stanley.)

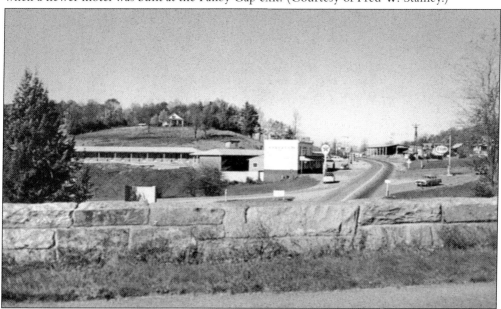

**BLUE RIDGE PARKWAY, FANCY GAP, CARROLL COUNTY, VIRGINIA.** At this point, the Blue Ridge Parkway and Highway 52 intersect, 8 miles from Hillsville, Virginia, and approximately 10 miles from the North Carolina state line. This 1950s photograph was taken from the bridge on the Blue Ridge Parkway looking north on Highway 52. Service stations, motels, and restaurants are provided for the motorist's convenience. (Courtesy of Haynes Distributing.)

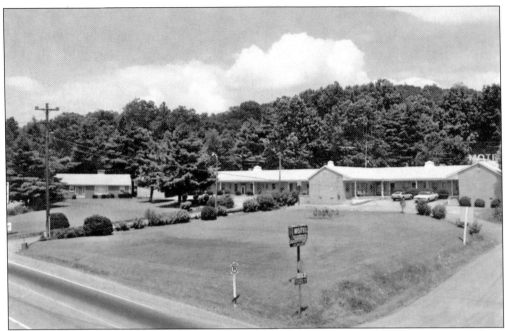

**MT. TOP MOTEL, FANCY GAP, VIRGINIA.** Mount Top Motel is located at the intersection of U.S. Highway 52 and the Blue Ridge Parkway at the Fancy Gap, Virginia, exit. This motel was built in 1955 by Mr. C. D. Phillips and his son. It is still family operated in 2005. (Courtesy of MWM Dexter.)

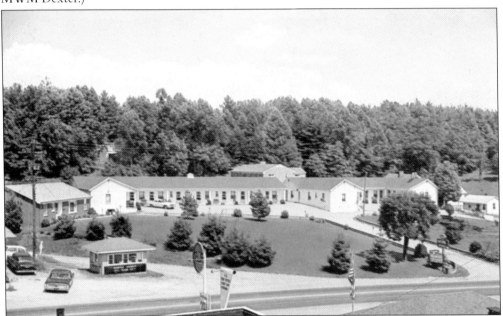

**MOUNTAIN TOP MOTEL, FANCY GAP, CARROLL COUNTY, VIRGINIA.** This vintage chrome postcard (c. 1955) contrasts with the previous postcards of the Mount Top Motel. In the early days, the motel was painted white with a red roof and showcased blue spruce trees on the lawn. When remodeled in the 1970s, the motel shell was covered with red brick. (Courtesy of Commonwealth Press, Inc.)

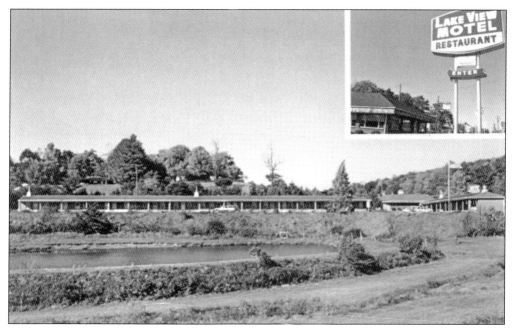

LAKE VIEW MOTEL AND RESTAURANT, FANCY GAP, CARROLL COUNTY, VIRGINIA. Originally owned and operated by Claude and Gaye Robinson, the Lake View Motel is located in Carroll County, Virginia, at the intersection of Highway 52 and the Blue Ridge Parkway at the Fancy Gap, Virginia, exit. This 1960s chrome postcard shows the backside of the motel from the parkway. (Courtesy of Creed Studios.)

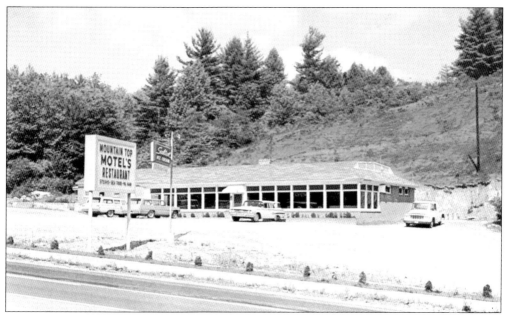

MT. TOP RESTAURANT, FANCY GAP, CARROLL COUNTY, VIRGINIA. Mount Top Motel is famous for its Sunday buffet lunches to the parkway visitors. They provide southwestern Virginia cuisine. Mr. C. D. Phillips built this restaurant about the same time as the Mount Top Motel. Built in 1955, this is a chrome-era postcard. (Courtesy of Commonwealth Press, Inc.)

**BUFFALO MOUNTAIN, FLOYD COUNTY, VIRGINIA.** Buffalo Mountain can be seen from the overlook near the Meadows of Dan exit on the Blue Ridge Parkway. Buffalo Mountain has an elevation of 5,250 feet above sea level. (Courtesy of W. A. Shaw Jr.)

**A VIEW OF PILOT MOUNTAIN, NORTH CAROLINA.** This chrome-era view of Pilot Mountain was snapped somewhere near Ground Hog Mountain in the late 1950s. Pilot Mountain is located between Mount Airy, North Carolina, and Winston-Salem, North Carolina. It is a designated state park. Officially it was opened as a state park in 1978. Prior to that it was owned and operated privately. (Courtesy of Colorpicture Publishers, Inc.)

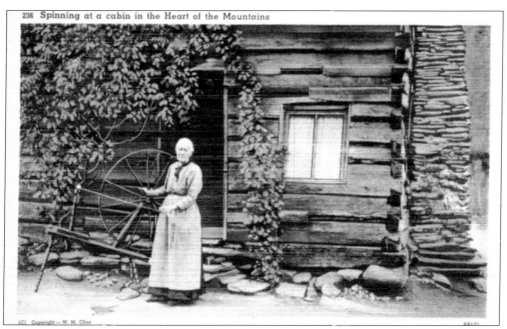

SPINNING AT A CABIN IN THE HEART OF THE MOUNTAINS. The earliest known knitters were from Europe. The type of spinning wheel pictured here in this linen-era postcard is a great wheel, a type of spindle wheel. It was designed specifically as a devise to rotate the spindle, which had been previously been done by hand. Spindle wheels were used to spin fine fibers. (Courtesy of W. M. Cline.)

MOUNTAIN LAUREL ALONG THE BLUE RIDGE PARKWAY. The rugged beauty of the Blue Ridge Mountains provides a strong contrast to delicate blossoms of mountain laurel (*Kalmia latifolia*). Several colors can be found during spring and summer, including white, pink, and hot pink. (Courtesy of Shenandoah Natural History Association.)

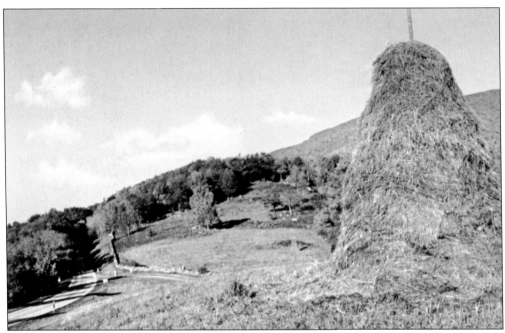

**HAYSTACK ALONG THE PARKWAY.** Not so long ago, haystacks like this one could be seen along the parkway on one of the many farms. Before farm equipment, farmers preserved their hay by stacking it around a pole in the field where it was cut. The outer layer formed a barrier protecting the inner layers of hay. (Courtesy of Eastern National Park and Monument Association.)

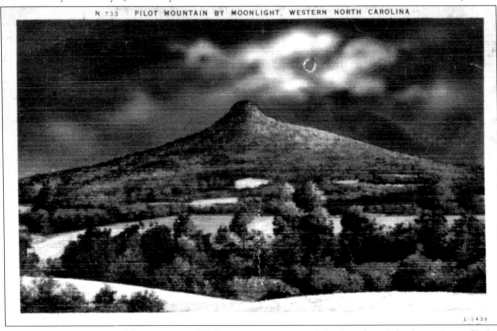

**PILOT MOUNTAIN BY MOONLIGHT.** This linen-era postcard depicts the nighttime view of Pilot Mountain. Pilot Mountain can be seen from the Blue Ridge Parkway near Fancy Gap, Virginia. Rising more than 1,400 feet, Pilot Mountain State Park was dedicated officially in 1976. During the Civil War, it was used as a scout lookout. (Courtesy of Asheville Post Card Company.)

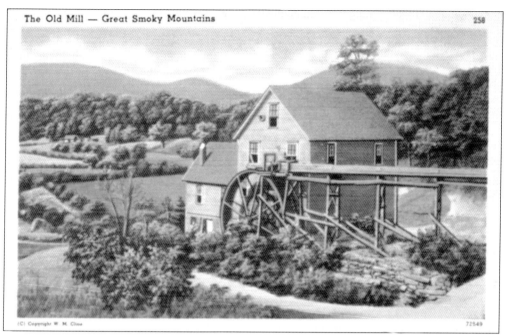

**THE OLD MILL.** This linen postcard has captured the essence of the Old Mill. In the Southern Mountain Region, several of these old mills are still standing. They were used to grind corn and wheat using water to turn the wheel. (Courtesy of W. M. Cline.)

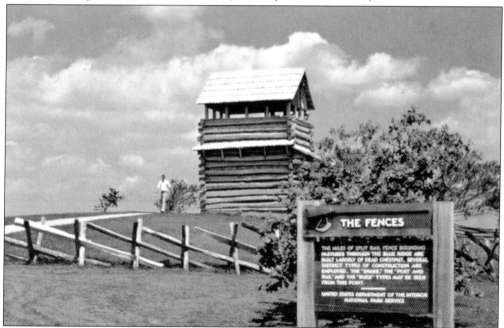

**GROUNDHOG MOUNTAIN OVERLOOK.** Located in Carroll County, Virginia, Groundhog Mountain has an elevation of 3,030 feet (milepost 188.8). The Observation Tower, simulating an old tobacco barn, affords a 360-degree view of the country side. Various types of old chestnut rail fences may be seen here. The CCC used a total of six different fence types. (Courtesy of W. A. Shaw.)

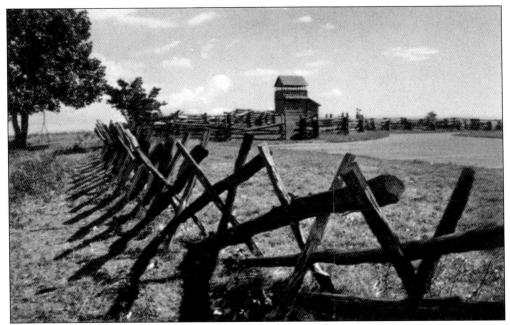

**RAIL FENCES AT GROUNDHOG MOUNTAIN.** The different rail fences in this area include Snake, Post and Rail, and Galloping or Rabbit. Numerous types of rail fences are used along the parkway. Shown in this chrome-era postcard is the lookout that was used to watch for fires. (Courtesy of National Park Concessions.)

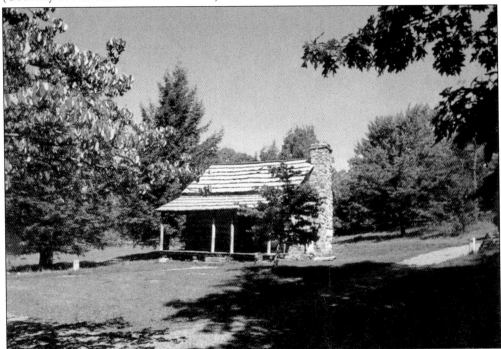

**FARM HOUSE AT HUMPBACK ROCKS.** This reconstructed farmhouse is found at Humpback Rocks (milepost 5.8) on the Blue Ridge Parkway. This is near Waynesboro, Virginia. Early settlers of the Shenandoah Valley built log homes when homesteading. (Courtesy of W. M. Cline.)

**BLUE RIDGE PARKWAY SCENES.** This multi-view chrome-era postcard is indicative of the advancement of technology for overlaying many scenes on one card. Scenes on this card from left to right and top to bottom include Dark Hollow Falls, Peaks of Otter, Dogface Rocks, Shenandoah National Park sign, mountain rural scenic, and Hemlock Forest Overlook. (Courtesy of Valley Views.)

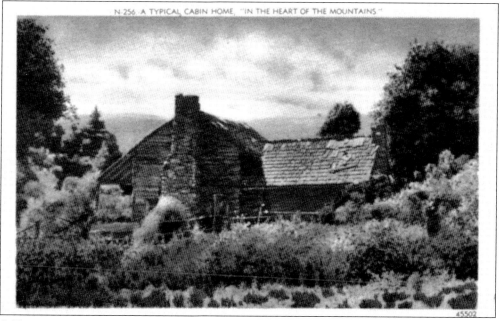

**A TYPICAL MOUNTAIN HOME "IN THE HEART OF THE MOUNTAINS."** Early Americans built log homes like this one pictured on this vintage linen-era postcard. They hand cut the logs and pulled them with either oxen or mules. Very few could afford horses. This is a two-story cabin with a loft. (Courtesy of Asheville Post Card Company.)

**BLUE RIDGE COUNTRY ROAD.** This curvy road can be found in almost any of the counties bordering the Blue Ridge Parkway. There are several types of fences used throughout the area, as shown in this linen-era postcard. This is a white rail fence found throughout Virginia and especially on horse farms in the Shenandoah Valley. (Courtesy of Asheville Post Card Company.)

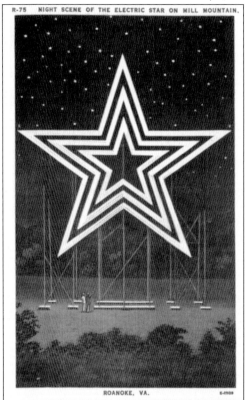

**NIGHT SCENE OF THE ELECTRIC STAR ON MILL MOUNTAIN.** The Mill Mountain exit is at milepost 120 on the parkway. The electric star is constructed on top of Mill Mountain, 1,800 feet above sea level and 975 feet above the city of Roanoke. The largest man-made illuminated star in the world stands 88 feet in diameter on a 100-foot structure and is as tall as an eight-story office building. Nine rows (2,000 feet) of neon tubing are used to light up the night sky. (Courtesy of Asheville Post Card Company.)

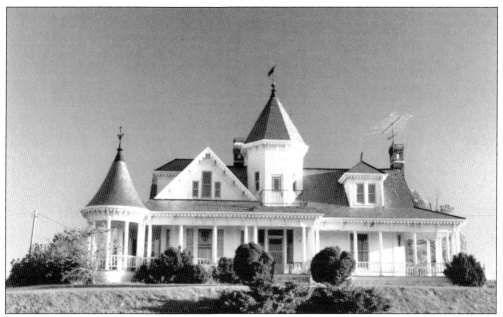

**THE J. SIDNA ALLEN HOME, FANCY GAP, VIRGINIA.** Taken sometime in the 1960s, this chrome-era postcard shows the beautiful J. Sidna Allen Home. It is located on Highway 52 between the Fancy Gap interchange and Hillsville, Virginia. Sidna was one of the Allen Clan involved in the Allen Tragedy at Hillsville, Virginia, on March 14, 1912. (Courtesy of W. A. Shaw Jr.)

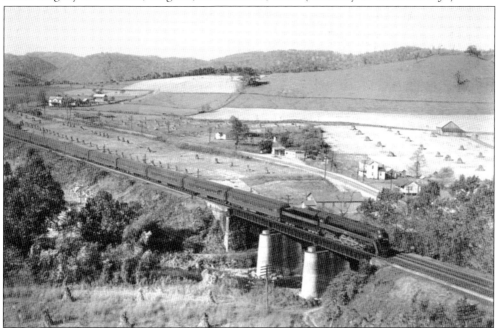

**RICH FARMING VALLEY OF THE BLUE RIDGE MOUNTAINS.** This chrome-era postcard has a typical rich farming valley that can be found in the Blue Ridge Mountains of Virginia. Once trains like this one traveled the rails from city to city hauling passengers and merchandise. Several of the rail lines were closed in the 1970s due to a change in transportation methods of the American people. (Courtesy of Haynes Distributing Company.)

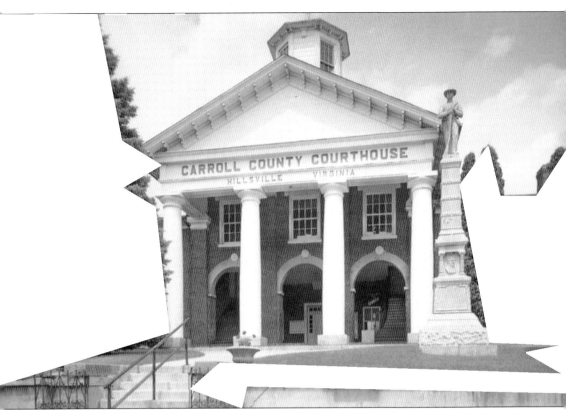

**CARROLL COUNTY, VIRGINIA COURTHOUSE.** Built in 1872 and later remodeled, the Carroll County courthouse was the site of the Allen Tragedy. In a bid to free one of their clan, the Allen family made headlines across America after the courtroom massacre on March 13, 1912. Two court officers, W. M. Foster and Sheriff Webb; Judge Thorton Massie; and one jurist, Augustus Fowler, were shot and killed following the conviction of Floyd Allen. Allen was found guilty of aiding an escaped prisoner, his nephew, and was sentenced to one year in the penitentiary. After the tragedy and manhunt that ensued, Virginia executed Claude Allen and Sidna Allen in the first electric chair execution in Virginia. Following was the largest funeral procession that Carroll County has ever had. Over 1,000 people attended the funeral. All of this occurred because Floyd's nephew stole a kiss at a corn shucking one year prior. The bullet holes can still be found. This chrome-era postcard shows the courthouse as it has been for many years. (Courtesy of W. A. Shaw Jr.)

## Two

# BLUE RIDGE PARKWAY, NORTH CAROLINA

*The grandeur of the scenery along this highway, comprising, as it will, extensive vistas into the Piedmont region, nearer views of valleys, and mountain tops, and ridges, with here and there a most attractive waterfall; and the highway crossing and passing streams of clear crystal water and penetrating the dense evergreen forests of balsam and spruce, whose deep shade always casts a feeling of awe over the traveler as he passes through them, will make the ride over this highway one never to be forgotten.*
—Col. Joseph Hyde Pratt

The Blue Ridge Parkway began in North Carolina with ground being broken at or near Cumberland Knob and finished at the Linn Cove Viaduct. A total of 54 years was required to complete the parkway.

In this chapter, the reader will see Col. Joseph Hyatt's vision of the "Mountain Road" through postcards. He was the director of the North Carolina Geological Economic Survey and understood the progress of the new automobile would improve the country's economy.

As early as 1909, survey work began for the creation of the mountaintop pleasure road. This road was to provide a pleasurable trip through the mountains so that the public could revel in the natural beauty of the landscape. The name had to imply its purpose: "The Crest of the Blue Ridge Highway." Today the trip between mile 317.6 and mile 318.7 drives along the approximate roadbed of the pioneer effort at the "Crest of the Blue Ridge Parkway."

By 1930, little had been done to improve the roads through the Appalachian Mountains. The Federal Land Planning Committee in 1935 revealed that many of the mountain counties in Virginia and North Carolina were acquiring their first gravel roads and numerous localities were said to be accessible only by horseback or "jolt wagon." Some counties like Floyd County, Virginia, did not have a single paved road.

Today several thousand miles of paved road exist through North Carolina, including the beautiful Blue Ridge Parkway. Countless postcards have been dedicated to this one scenic highway, as you will see in this chapter.

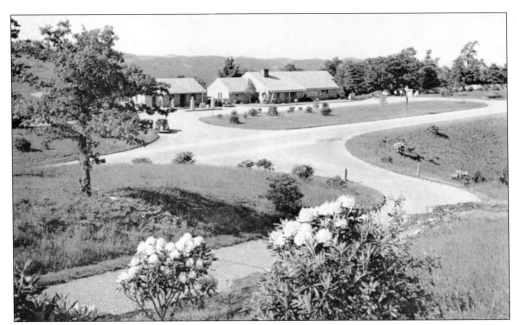

THE BLUFFS COFFEE SHOP IN DOUGHTON PARK. Located at milepost 238.5 and 244.7 in Alleghany County, North Carolina, Doughton Park is a landscape of open meadows and pioneer cabins, a place to view wildlife and get a feel for the lives of those who lived here long ago. This is a great stop for country ham and eggs on a cold fall morning. (Courtesy of National Park Concessions.)

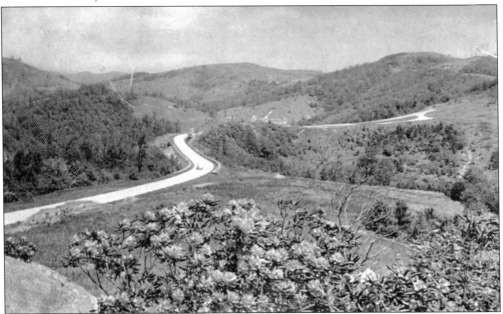

BLUE RIDGE PARKWAY IN DOUGHTON PARK. Doughton Park is one of the best places along the motor road to view white-tailed deer, raccoons, red and gray foxes, bobcats, and spectacular shows of flame azalea and rhododendron in the late spring. As seen in this chrome-era postcard, many types of wildflowers can also be found within the many trails that have been preserved for the day hiker. (Courtesy of National Park Concessions.)

**HARVEST TIME IN THE SUNNY SOUTH.**
Tobacco farming was the livelihood of many farmers in the Southern states until the 1990s. In this linen-era postcard, tobacco is hung to dry in the warm summer sun. Tobacco markets were set up on warehouses throughout Virginia and North Carolina for the farmers to sell their crops. (Courtesy of Asheville Post Card Company.)

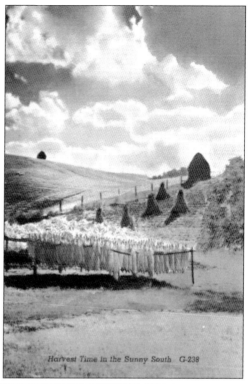

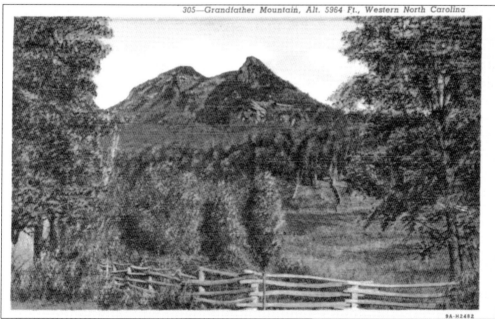

**GRANDFATHER MOUNTAIN, ALT. 5964 FT., WESTERN NORTH CAROLINA.** Privately owned, Grandfather Mountain is one of the main attractions in the Blue Ridge Mountains of Avery County, North Carolina. This vintage linen-era postcard depicts the splendid work of God and a quiet country setting. The Linn Cove Viaduct circumvents Grandfather Mountain. The plan was to build the viaduct by cutting as few trees as possible. (Courtesy of Curt Teich and Company, Inc.)

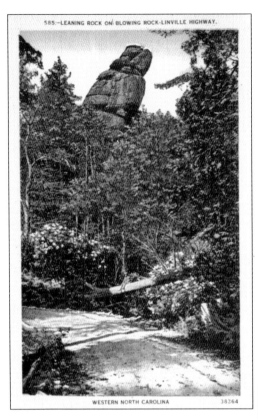

**LEANING ROCK ON BLOWING ROCK–LINVILLE HIGHWAY.** One of the oldest resort areas in Appalachia, Blowing Rock has been a resort destination since 1889. The town was built in the 1880s. The town's namesake, the Blowing Rock, is located at milepost 291.1 on the Blue Ridge Parkway. Blowing Rock is an enormous cliff towering thousands of feet above the John's River Gorge. Rock walls create a funnel for the wind that returns objects from where they were thrown—like a boomerang. (Courtesy of Asheville Post Card Company.)

**THAT OLD CABIN HOME.** Poet Harry Russell Wilkins of Spartanburg, South Carolina, wrote this poem about the typical mountain home in 1946. He wrote several verses that were used on linen-era postcards during the 1940s. (Courtesy of Asheville Post Card Company.)

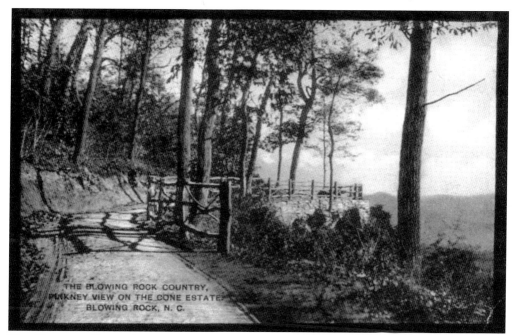

**THE BLOWING ROCK COUNTRY, PINKNEY VIEW OF THE CONE ESTATE.** This vintage linen-era postcard has a black border that is uncommon. Most had white borders. Dirt country roads and trails like this one are few in the 21st century. Visitors can stroll or horseback ride the same roads that Moses Cone, founder of Cone Cotton Mills, built for his country retreat at milepost 294.

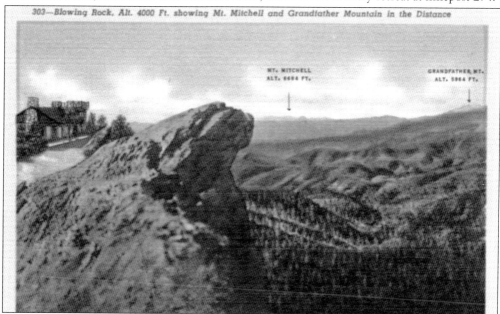

**BLOWING ROCK.** A far-flung panorama of magnificent mountain scenery that is unsurpassed can be seen from Blowing Rock. Here wind currents defy the laws of nature, and it is said that if a light object, such as a handkerchief or a straw hat, is thrown from the rock, it will be blown back by the force of the wind sweeping up from the gorge below—believe it or not. (Courtesy of Curt Teich and Company, Inc.)

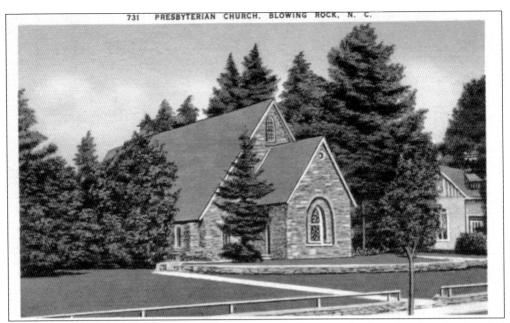

**RUMPLE PRESBYTERIAN CHURCH, BLOWING ROCK, N.C.** The first church to be founded in Blowing Rock, on the first Sunday of 1886, was Rumple Presbyterian Church. Dr. Jethro Rumple dedicated a frame structure on the present site of the stone structure. The new stone church building took shape from a rough 1905 pencil sketch. Work was completed in 1912. The portico was added in 1920. (Courtesy of Asheville Post Card Company.)

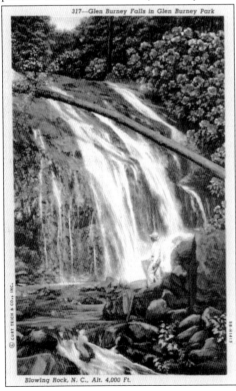

**GLEN BURNEY FALLS IN GLEN BURNEY PARK.** The trail to Glen Burney begins on Main Street in Blowing Rock. Exit at milepost 291.1 for Blowing Rock. A hike will take you through a park and past New Years Creek. This linen-era postcard has a man standing at the base of the falls showing the magnitude of the height of the 50-foot falls. (Courtesy of Curt Teich and Company, Inc.)

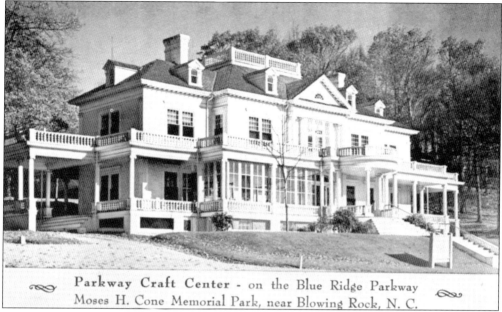

**MOSES CONE FLAT TOP MANOR HOUSE, PARKWAY CRAFT CENTER.** The late 19th century saw the emergence of a new upper class, composed of those men who had made their fortunes in the Gilded Age. Textile entrepreneur Moses H. Cone purchased 3,600 acres of land near Blowing Rock and built one of North Carolina's premier turn-of-the-century country estates as seen in this vintage black-and-white-era postcard. Cone founded the Cone Cotton Mills in Greensboro, North Carolina, in the 1890s. (Courtesy of Hans L. Raum.)

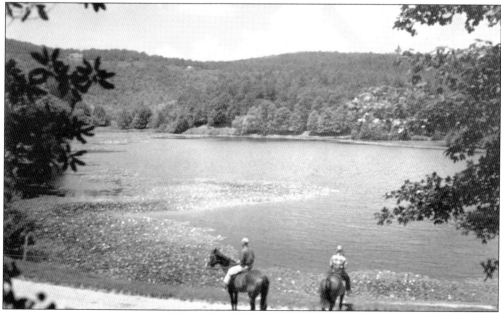

**BASS LAKE AT THE MOSES CONE MEMORIAL PARK, BLOWING ROCK, NORTH CAROLINA.** Located on the Blue Ridge Parkway, this park is very popular with tourists. In the distance may be seen the manor house. Bass fishing is a favorite pastime for outdoorsman in the Carolina mountains. (Courtesy of W. M. Cline.)

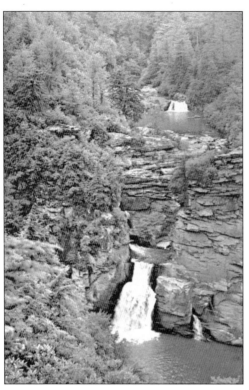

**LINVILLE FALLS.** Hosting 50,000 visitors annually, Linville Falls is the most visited waterfall in the Blue Ridge Mountains. In 1989, it was designated a Natural Heritage Area. The headwaters of the Linville River begins at Grandfather Mountain, and the water flows through the Catawba Valley. The area was called Linville to honor the explorer William Linville, who in 1766 was attacked and killed by the local Native Americans in the gorge. (Courtesy of Asheville Post Card Company.)

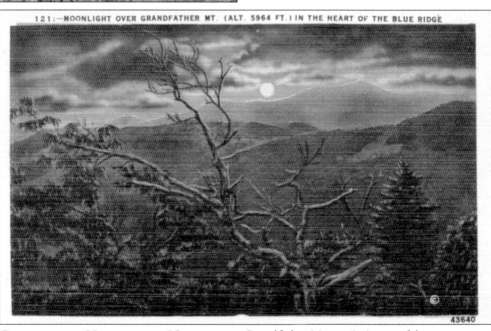

**GRANDFATHER MOUNTAIN BY MOONLIGHT.** Grandfather Mountain is one of the most rugged mountains in the Blue Ridge and east of the Rockies. Since August 1955, the official U.S. Weather Service Reporting Station, located at the Swinging Bridge Visitor Center, has been providing daily weather observations. On April 18, 1997, the highest wind speed ever recorded at Grandfather Mountain was 196 mph. (Courtesy of Asheville Post Card Company.)

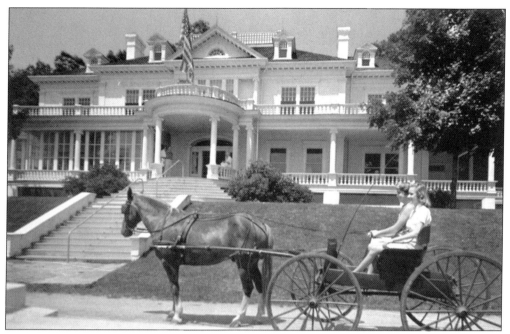

**FAÇADE OF THE MANOR HOUSE IN MOSES CONE MEMORIAL PARK.** Many horse trails cover the park grounds. Moses Cone built roads for leisure rides through the country and for the fascination of just building them at his mountain escape, the manor house. This park requires so much maintenance that there is not enough funding to finish all levels, and only the main level is restored. (Courtesy of W. M. Cline.)

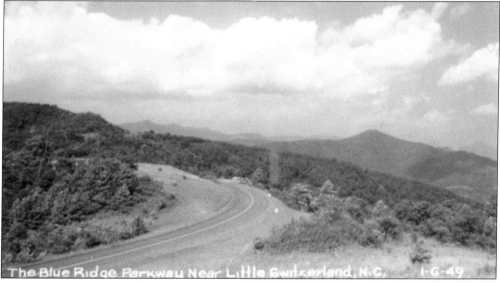

**THE BLUE RIDGE PARKWAY NEAR LITTLE SWITZERLAND, NORTH CAROLINA.** Located at milepost 331 between Boone and Asheville is the scenic town of Little Switzerland, McDowell County, North Carolina. Several museums are located in McDowell County including the Museum of North Carolina Minerals, Carson House, Overmountain Victory National Historic Trail (OVNHT), and several others. This black-and-white-era postcard was photographed sometime in the late 1930s. (Courtesy of W. M. Cline.)

LINVILLE MOUNTAIN RANGE FROM LITTLE SWITZERLAND, NORTH CAROLINA. Table Rock Mountain can be seen in this chrome-era postcard from the 1950s. This is one of the many beautiful scenic mountain views seen from Little Switzerland. Known for its great scenic beauty, Little Switzerland was a favorite vacation spot before the parkway was built. (Courtesy of W. M. Cline.)

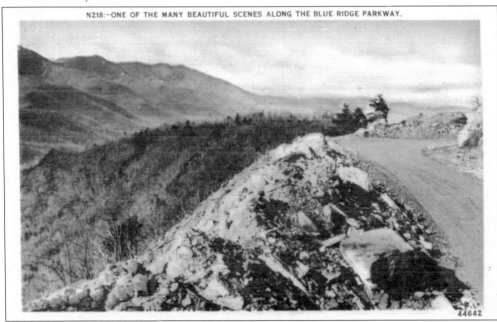

A BEAUTIFUL SCENE ALONG THE BLUE RIDGE PARKWAY. Produced sometime during the late 1930s, this linen-era postcard is of a beautiful scene along the Blue Ridge Parkway. Many pullovers were created for viewing the mountain-side scenery by the CCC. They hand built the rock walls and planted wild flowers and trees to frame the views. (Courtesy of Asheville Post Card Company.)

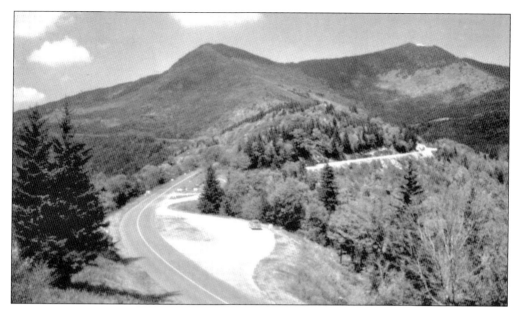

**MOUNT MITCHELL INTERSECTION ON THE BLUE RIDGE PARKWAY.** Mount Mitchell State Park at milepost 355.3 was incorporated into the Blue Ridge Parkway because of its great beauty and because of the lower temperatures during the summer. It is part of the Black Mountain range of Western North Carolina and retains its dramatic height of 6,684 feet. The climate of the Black Mountains is like that of Canada. (Courtesy of Asheville Post Card Company.)

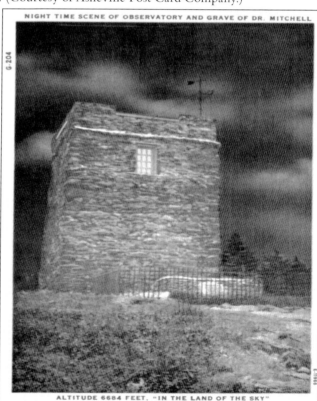

**NIGHT TIME SCENE OF OBSERVATORY AND GRAVE OF DR. MITCHELL.** This linen-era postcard depicts the observatory atop Mount Mitchell. Dr. Elisha Mitchell, scholar and teacher from the University of North Carolina, lies buried on the top of Mount Mitchell. His one-way trip to the summit in 1857 led to his death as the result of a fall. (Courtesy of Asheville Post Card Company.)

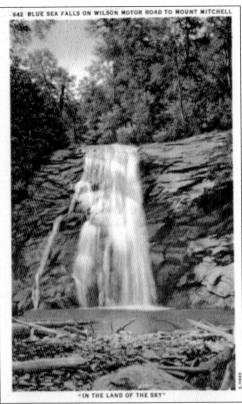

**BLUE SEA FALLS (MOUNT MITCHELL FALLS) ON WILSON MOTOR ROAD TO MOUNT MITCHELL.** Privately owned and not currently open to the public, Blue Sea Falls is also known as Mount Mitchell Falls. They are located on private property near Mount Mitchell. Mount Mitchell Falls has a 40-foot drop. This is the scene where Dr. Elisha Mitchell fell to his death in 1857. (Courtesy of Asheville Post Card Company.)

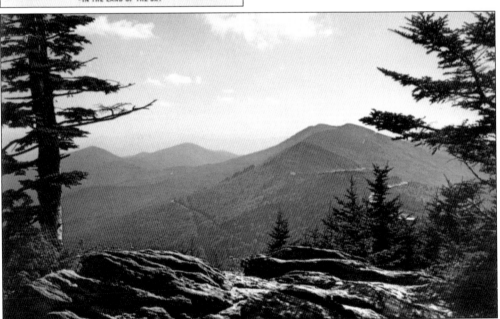

**SOUTHERN VIEW FROM THE SUMMIT OF MT. MITCHELL.** Walter Cline captured this scene looking south from the summit of Mount Mitchell sometime in 1959. He had a fondness for the mountains that can be seen in his photographic works, like this chrome-era postcard. Mount Mitchell was the first North Carolina State Park in 1915. (Courtesy of W. M. Cline.)

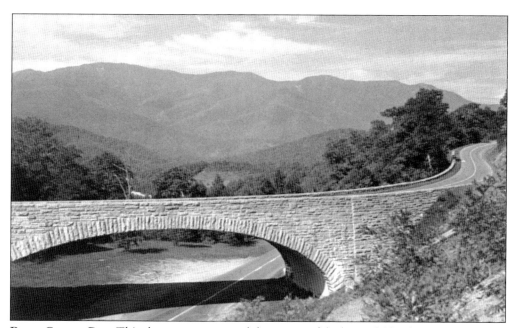

**BUCK CREEK GAP.** This chrome-era postcard shows one of the beautiful bridges constructed by the CCC. Rock was mined locally and shaped into blocks to be placed on the façade of bridges and overlooks. John D. Rockefeller was particularly impressed with the craftsmanship that went into the bridge construction. (Courtesy of W. M. Cline.)

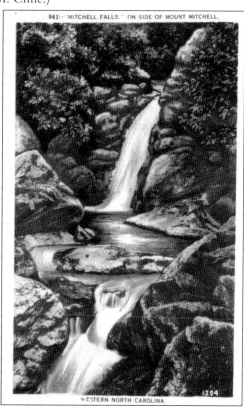

**MITCHELL FALLS ON SIDE OF MOUNT MITCHELL.** Mitchell Falls, on the side of Mount Mitchell, is in the Black Mountain Range. (Courtesy of Asheville Post Card Company.)

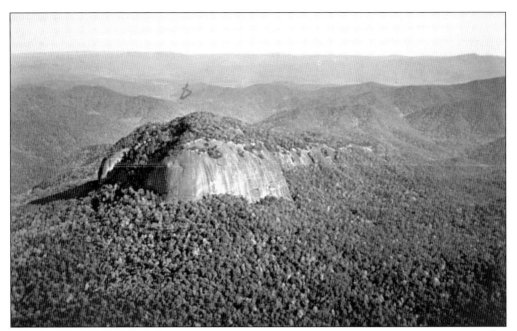

**LOOKING GLASS ROCK–PISGAH NATIONAL FOREST, BREVARD, NORTH CAROLINA.** This 1960s chrome-era postcard shows the magnificence of Looking Glass Rock, located at milepost 417. Looking Glass Rock is pure granite and stands 3,969 feet. The parking overlook has an elevation of 4,493 feet. When the sun shines brightly, the rock mountain looks like a looking glass reflecting the sun's rays. (Courtesy of W. M. Cline.)

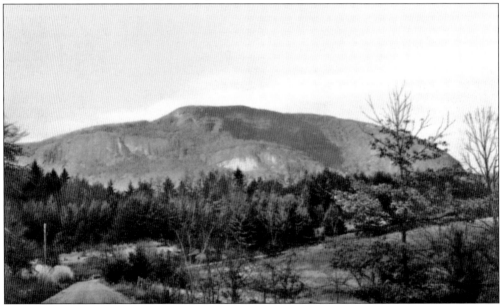

**WHITESIDE MOUNTAIN BETWEEN CASHIERS AND HIGHLANDS, NORTH CAROLINA.** Located on U.S. Interstate 64, Whiteside Mountain rises 4,930 feet and commands a view of four states. Rhododendron and laurel bloom in profusion atop the mountain, which has so many kinds of plant life that it is a botanist's paradise. From the parking area, hiking trails lead to Devil's Courthouse and Fat Man's Misery. (Courtesy of Asheville Post Card Company.)

**MOUNTAIN CRAFT CO., CHIMNEY ROCK, NORTH CAROLINA.** This black-and-white-era postcard of the Mountain Craft Company was taken by Walter Cline sometime in the 1930s. With the increase in tourism, locals found a great avenue to sell their handmade crafts and canned goods for more income. (Courtesy of Cline Photo Company.)

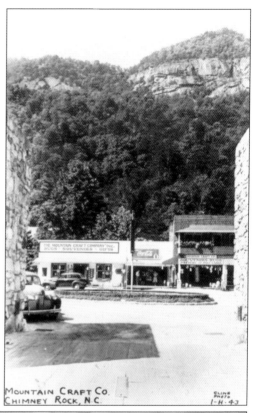

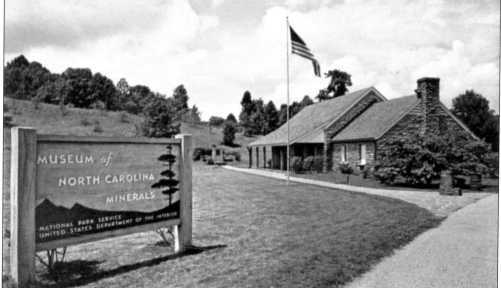

**MUSEUM OF NORTH CAROLINA MINERALS.** The Museum of North Carolina Minerals introduces the treasures found in the Spruce Pine Mining District through interactive displays on a wide variety of minerals and gems that are found in the region. Located at milepost 331 on the Blue Ridge Parkway at Gillespie Gap, the museum provides an introduction to the importance of mining in the region and the mineral and gem wealth found here. (Courtesy of W. M. Cline.)

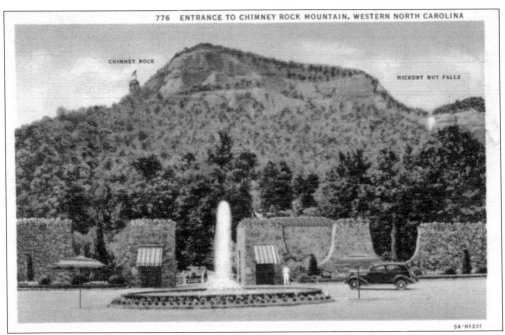

**ENTRANCE TO CHIMNEY ROCK MOUNTAIN, WESTERN NORTH CAROLINA.** Postmarked September 1937, this linen-era postcard was sent to Louisville, Kentucky, from Asheville, North Carolina. Depicted is the entrance to Chimney Rock with massive walls, gardens, flower-topped pylons, and fountains—a gateway to the wonders of Chimney Rock. (Courtesy of Asheville Post Card Company.)

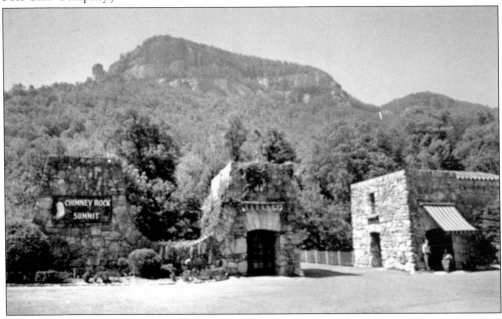

**ENTRANCE TO CHIMNEY ROCK PARK.** This chrome-era postcard taken sometime in the 1960s gives us another view of the entrance to Chimney Rock Park, which is located off of Highway 74 in Western North Carolina. You can reach Chimney Rock from milepost 384.7 on the Blue Ridge Parkway. (Courtesy of Asheville Post Card Company.)

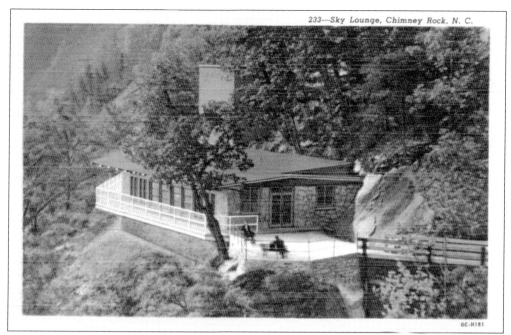

**SKY LOUNGE, CHIMNEY ROCK, NORTH CAROLINA.** Postmarked August 1951, this linen-era postcard was mailed from Brevard to Mount Joy, Pennsylvania, from Ralph and Ada. They said that they could "see all over the world" from the Sky Lounge. Today Sky Lounge is a unique shopping experience and snack bar. (Courtesy of Curt Teich and Company, Inc.)

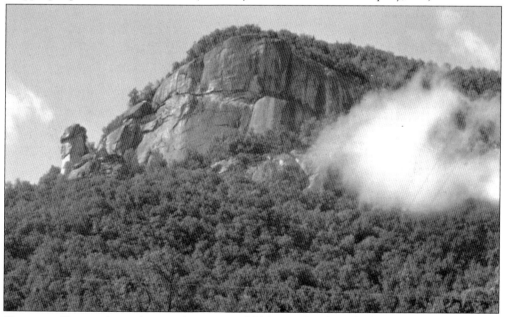

**CHIMNEY ROCK.** An early morning scene of Chimney Rock and Chimney Rock Mountain in Chimney Rock Park in Western North Carolina displays the wonderful misty fog found in the Blue Ridge. Visitors can ride up an elevator 26 stories through solid granite to see the rock. Several scenes from the 1992 movie *Last of the Mohicans* were filmed here, including the climactic fight scene at the falls. (Courtesy of Asheville Post Card Company.)

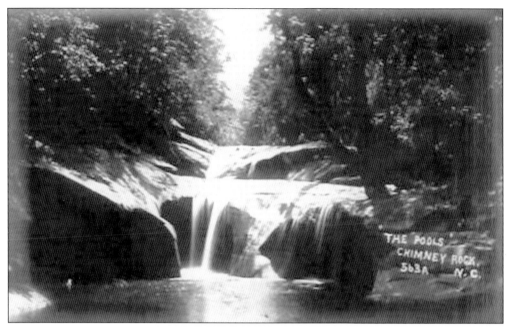

THE POOLS AT CHIMNEY ROCK. Hickory Nut Falls, located within Chimney Rock Park, is a 1.5-mile hike round-trip. Pools of cool mountain water can be found at the base of the falls as shown in this black-and-white-era postcard taken sometime in the late 1920s or early 1930s. This is an example of a photograph that was printed onto postcard paper. (Courtesy W. M. Cline.)

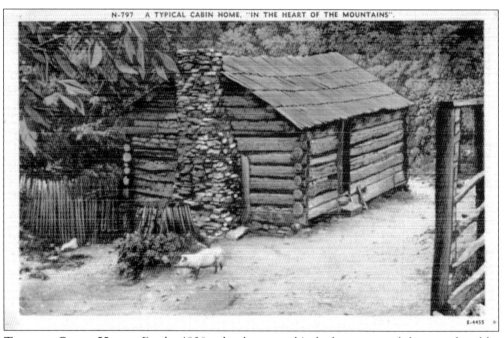

TYPICAL CABIN HOME. By the 1930s, the dogtrot cabin had pretty much been replaced by the frame house. Design of the dogtrot cabin is simple with two rooms and a hallway running between them. During the summer, the dogs would lay in the hallway to stay cool and out of the sun. (Courtesy of Asheville Post Card Company.)

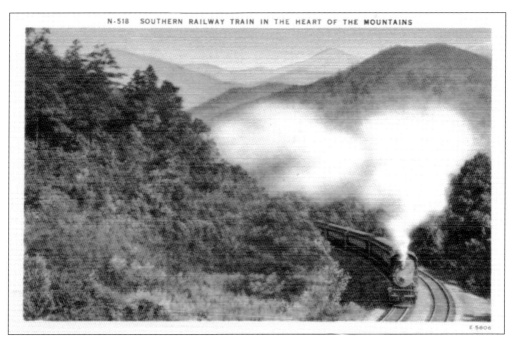

**SOUTHERN RAILWAY TRAIN IN THE HEART OF THE MOUNTAINS.** Transportation at the beginning of the 20th century opened travel to secluded mountain communities. Tourism became a new industry, providing new opportunities for the locals and vacations for the weary. Southern Railway is the final product of nearly 150 predecessor lines that were combined, reorganized, and recombined since the 1830s. (Courtesy of Asheville Post Card Company.)

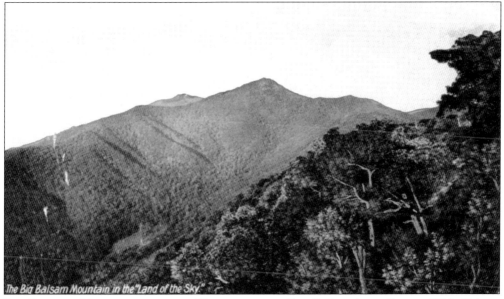

**BIG BALSAM MOUNTAIN IN THE "LAND OF THE SKY."** Found at milepost 359.8, Balsam Mountain towers over the landscape as seen in this blue-sky-era postcard. This postcard was postmarked 1911 and was sent to Russelville, Tennessee. Balsam trees are found only at higher elevations. They are in danger of being destroyed by insects during the 21st century. (Courtesy of Hackney and Moule Company.)

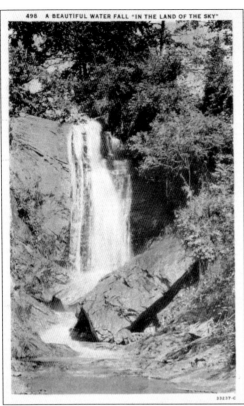

**A BEAUTIFUL WATERFALL IN THE LAND OF THE SKY.** There are nine different types of waterfalls including cascade, block, plunge, horsetail, segmented, tiered, cataract, fan, and punchbowl. The type of fall depends on the force, direction, and source of the water. (Courtesy of Asheville Post Card Company.)

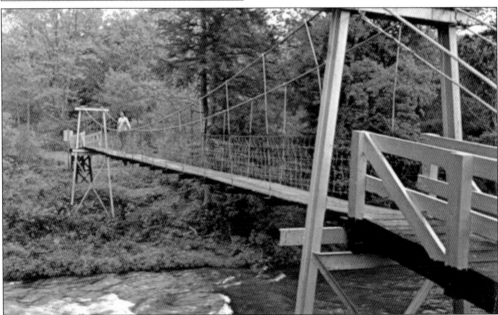

**PICTURESQUE SWINGING BRIDGE.** This is one of several swinging bridges that cross the South Toe River located on Highway 80, between Micaville and Buck Creek Gap and the entrance to the Blue Ridge Parkway in Western North Carolina. They were constructed of wood and large ropes and swayed when in use. (Courtesy of W. M. Cline.)

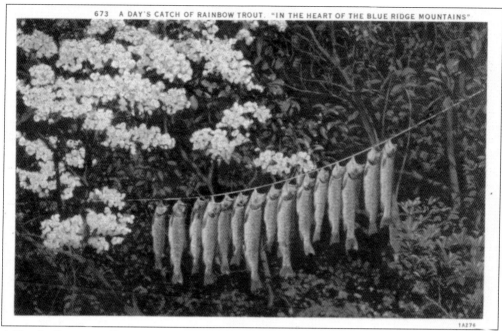

**A Day's Catch of Rainbow Trout.** This linen-era postcard shows one of the most popular pastimes in the Blue Ridge, which is fishing for rainbow trout. Located at milepost 344, access can be gained to the Toe River. The South Toe River area is located in Yancey County, North Carolina. Occasionally large rainbow trout are caught on the middle of the South Toe River. (Courtesy of Asheville Post Card Company.)

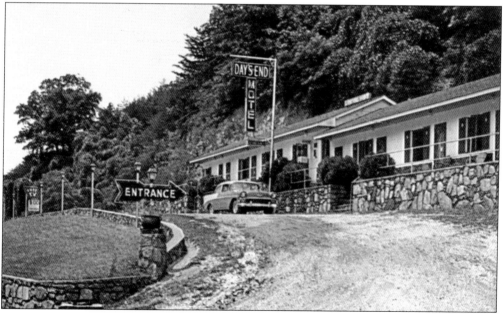

**Day's End Motel, Canton, North Carolina.** In one hour's drive to the Great Smoky Mountains National Park on U.S. Highway 19 and 23, the Day's End Motel had family accommodations with tub and shower baths. Chrome-era postcards were produced for motels like this one all over the country in the 1960s. (Courtesy of Fred W. Stanley.)

ONE OF THE NUMEROUS WATERFALLS "IN THE HEART OF THE BLUE RIDGE." Waterfalls are mystical, serene places of solitude. Surrounding these swirling drops, one will find lush greenery of the mountain laurel, ferns, and moss. Some waterfalls are on the side of the road, while other waterfalls are a short hike away from the parkway. They are fed by mountain streams gushing and rushing to the ocean. All waterfalls are different, taking on different shapes and forms. One waterfall might flow over several cascades, while another might plunge into a large pool and then cascade down a stream. (Courtesy of Asheville Post Card Company.)

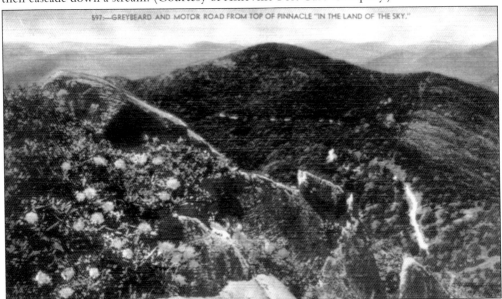

GREYBEARD AND MOTOR ROAD NEAR PINNACLE MOUNTAIN, NORTH CAROLINA. Pinnacle Mountain is located 20 miles south of Lake Lure, North Carolina, in the Blue Ridge Mountain range. The Pinnacle Mountain Trail is 4.1 miles with a total elevation gain of 2,332 feet. This is a strenuous trail and it is recommended that you bring lots of water. (Courtesy of Asheville Post Card Company.)

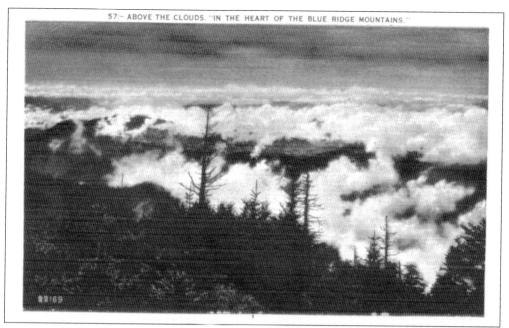

**ABOVE THE CLOUDS.** On any given day, riding the Blue Ridge Parkway in Western North Carolina can take you above the clouds, as seen in this vintage linen-era postcard. Riding and swaying in and out of the clouds gives the visitor the feeling of floating in the trees. (Courtesy of Asheville Post Card Company.)

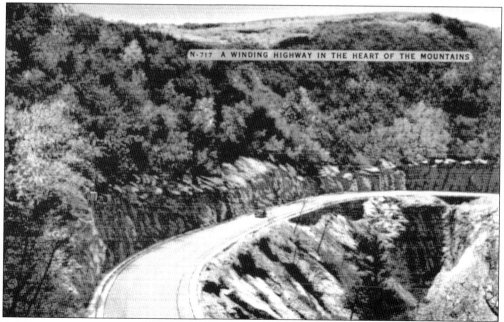

**A WINDING HIGHWAY IN THE HEART OF THE MOUNTAINS.** This description describes the Blue Ridge Parkway the best. It is a slowly winding highway that goes from mountaintop to mountaintop. This very old linen-era postcard was printed before guardrails were installed. (Courtesy of Asheville Post Card Company.)

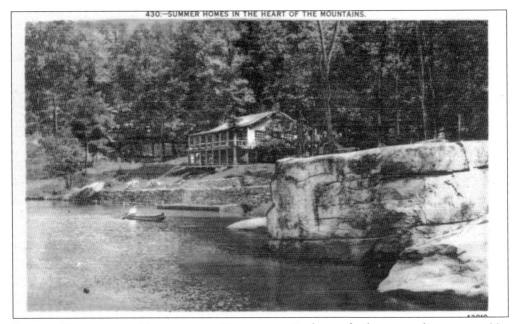

**SUMMER HOMES IN THE HEART OF THE MOUNTAINS.** Real estate for the surrounding communities near the parkway continues to boom in the 21st century. For over 100 years, it has been a fashionable retreat for Americans. The early resort communities included Blowing Rock and Asheville, North Carolina, and Elkmont, Tennessee. (Courtesy of Asheville Post Card Company.)

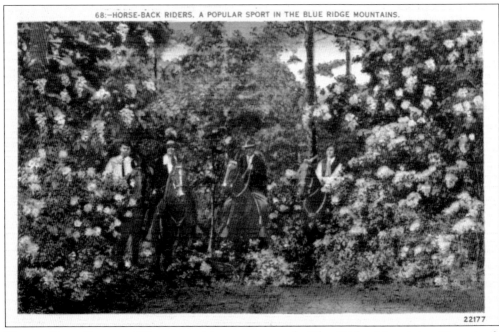

**HORSE-BACK RIDERS.** What an exciting way to see the Blue Ridge Mountains. Many trails are open to pedestrians, bikers, and horseback riders on the Blue Ridge Parkway. The views are breathtaking any time of the year. (Courtesy of Asheville Post Card Company.)

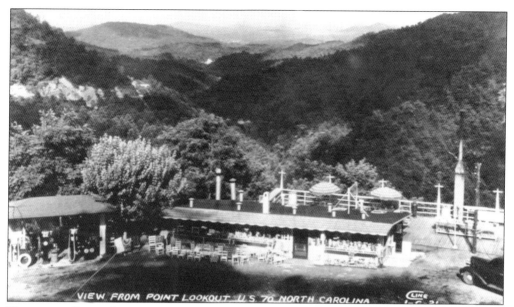

**VIEW FROM POINT LOOKOUT, U.S. 70 NORTH CAROLINA.** This black-and-white-era postcard was taken by Walter Cline sometime in the late 1930s. This was one of many lookouts and gift shops that sprouted up during the construction of the Blue Ridge Parkway. (Courtesy of W. M. Cline.)

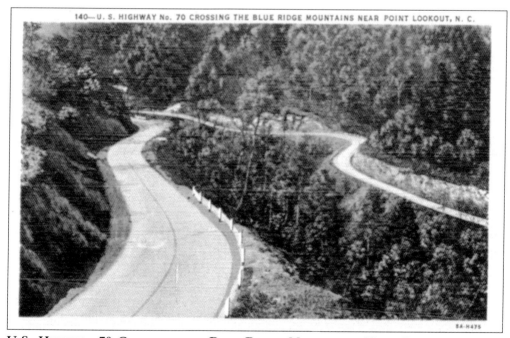

**U.S. HIGHWAY 70 CROSSING THE BLUE RIDGE MOUNTAINS NEAR POINT LOOKOUT, N.C.** Winding mountain roads going up and around the bend were depicted in many linen-era postcards like this one. Old Fort is a tiny rail town that the old Central Highway and now U.S. 70 goes through. The Central Highway can be followed by taking a right onto Mill Creek Road from U.S. 70. (Courtesy of Curt Teich and Company, Inc.)

**PARKWAY PLAYHOUSE AND ART CENTER, BURNSVILLE, N.C.** The Parkway Playhouse and Art Center provides local theater entertainment and training for young actors. The University of North Carolina at Greensboro provides the actors and actresses that perform here. This has become an entertainment tradition for Burnsville. Seen in this 1960s chrome-era postcard is a red barn-like structure located just off of the Blue Ridge Parkway. (Courtesy of W. M. Cline.)

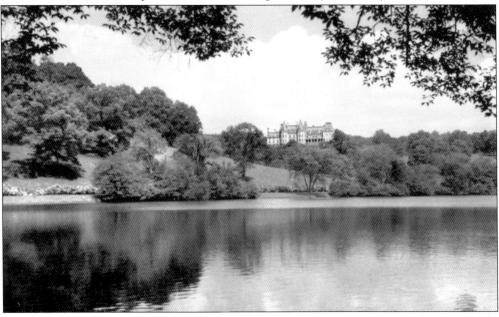

**BILTMORE HOUSE AND GARDENS, AMERICA'S FINEST HOME.** Biltmore was the home of the late George W. Vanderbilt and contains many art treasures gathered from all parts of the world. The estate comprises over 12,000 acres of beautifully landscaped grounds, forests, and fields, and the house and gardens are open to visitors. Taken in the 1960s, this chrome-era postcard draws in the magnificence of the Biltmore Estate. (Courtesy of Asheville Post Card Company.)

# Three

# SHENANDOAH NATIONAL PARK AND SKYLINE DRIVE

*Man's vision, combined with his engineering skill, brought forth on the mountaintop a strip of asphalt running . . . from ridge to ridge and gap to gap in such a gentle fashion that it was the driving equivalent of a city boulevard.*
—Harley Jolley, *The Blue Ridge Parkway*

Shenandoah National Park, dedicated on July 1, 1936, is located in the Piedmont region of Virginia and extends a distance of approximately 65 miles along the crest of the Blue Ridge between Front Royal on the north and Waynesboro on the south. The park is best known for the Skyline Drive, a 105-mile scenic highway that runs the entire length of the mountains.

In this chapter, the reader will learn about the construction and beauty of Skyline Drive located in Shenandoah National Park through beautiful vintage postcards. The park was authorized on May 22, 1926, and established in December 26, 1935. Before becoming a national park, most of the land was privately farmed. The State of Virginia slowly acquired the land from the landowners and then dutifully gave it to the federal government on the contingency that it be designated a national park.

For the creation of the park, a number of families and communities were required to vacate portions of the Blue Ridge Mountains. Five hundred homes were vacated in the eight counties affected. Most families touched by this were from Madison, Page, and Rappahannock Counties. A little-known fact is that while many were forced to move, several residents were allowed to stay for the duration of their life.

Shenandoah Valley is so beautiful that Pres. Herbert Hoover picked a 164-acre site within the park on the Rapidan River for what would become a presidential retreat, Camp Hoover. It preceded the current presidential retreat, Camp David. Camp Hoover is located at the end of Mill Prong Trail, which is accessible at milepost 52.5.

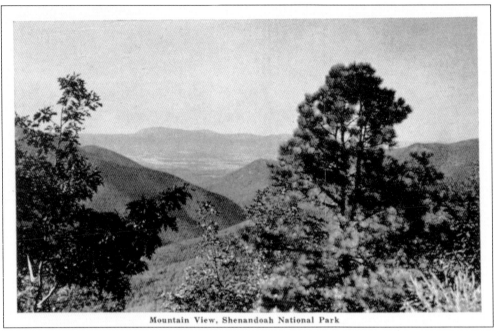

MOUNTAIN VIEW, SHENANDOAH NATIONAL PARK. This is an early black-and-white real-photo postcard of a scenic view, probably taken during the mid-1930s. Visitors can see for themselves why John Denver crooned so passionately about the winding country roads of the Blue Ridge Mountains and Shenandoah River. (Courtesy of Graycraft Card Company.)

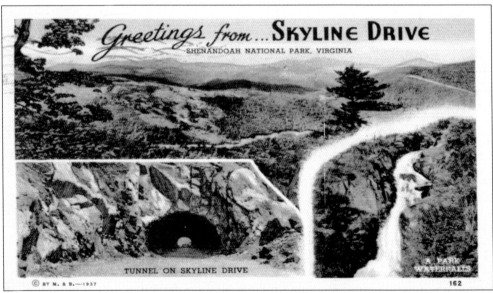

GREETINGS FROM . . . SKYLINE DRIVE: SHENANDOAH NATIONAL PARK. This linen postcard has three views. Some thought this method gave more for the money. A picturesque scene, the tunnel along Skyline Drive, and a beautiful waterfall grace this card that is postmarked 1940. (Courtesy of Marken and Bielfeld, Inc.)

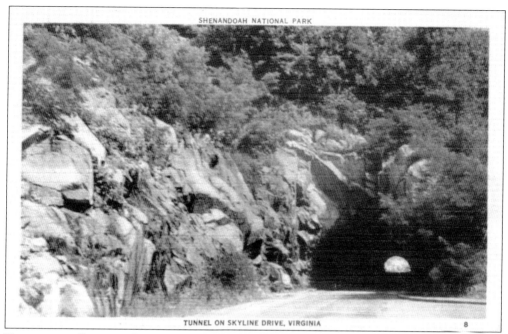

**TUNNEL ON SKYLINE DRIVE, VIRGINIA.** This very rare, colorized real-photo postcard was postmarked in 1947. The driver literally can get into the mountain through this man-made tunnel, carved into the mountainside, on Skyline Drive. Engineers of the CCC decided, rather than tear away the side of the mountain, to save it and bore a hole from one side to the other when building this scenic road. (Courtesy of Everett Waddey Company.)

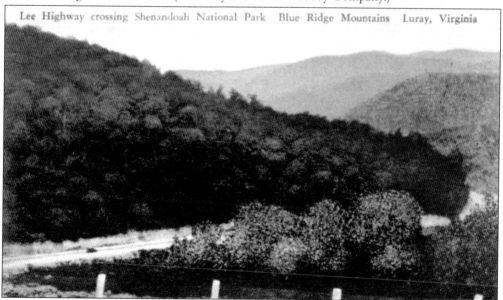

**LEE HIGHWAY CROSSING SHENANDOAH NATIONAL PARK, BLUE RIDGE MOUNTAINS, LURAY, VIRGINIA.** The Mimslyn Inn in Luray, Virginia, sold this linen postcard. An early automobile can be seen on the road to the left. From the photograph, it appears that this is a dirt road. The Mimslyn Inn was built in 1931 for the discriminating Southern visitor. (Courtesy of the Albertype Company.)

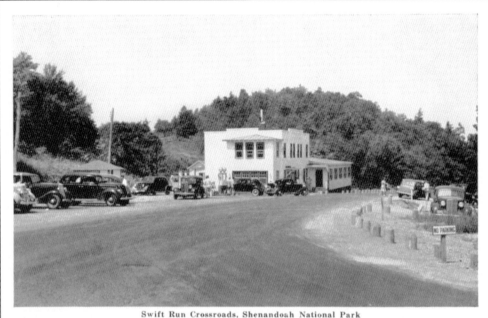

**SWIFT RUN CROSSROADS, SHENANDOAH NATIONAL PARK.** With the increased production of automobiles came the increase in roadside cafés, motels, and service stations like the one pictured here. This is a real-photo postcard that is dated 1935. Many of the roadside businesses had postcards printed just to be sold at their establishment. (Courtesy of Graycraft Card Company.)

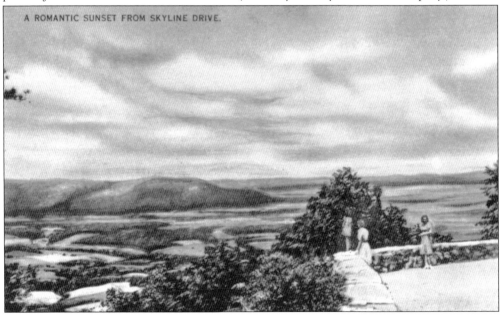

**ROMANTIC SUNSET FROM SKYLINE DRIVE.** Thanks to Herbert Hoover's resolve and FDR's vision to put America to work, construction on Skyline Drive began by the CCC in April 1933. A rough and primitive road was already in place then, but it was only used by farmers and timbermen. A real road, paved and landscaped, was about to emerge. (Courtesy of A. J. Simonpietri Jr.)

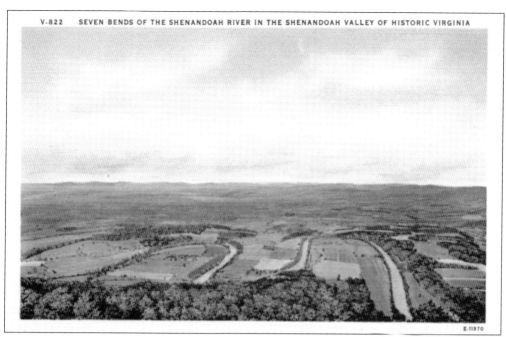

**SEVEN BENDS OF THE SHENANDOAH RIVER IN THE SHENANDOAH VALLEY OF HISTORIC VIRGINIA.** Many centuries old, the Shenandoah River has provided water, food, and transportation to sustain human and animal life. The present-day paddler on the Shenandoah River will see things as they might have been seen before the Civil War, along with the addition of an occasional concrete bridge, power line, and tractor. (Courtesy of Asheville Post Card Company.)

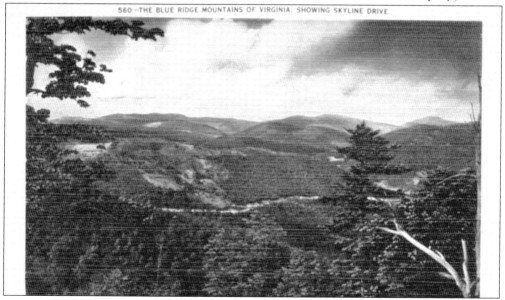

**THE BLUE RIDGE MOUNTAINS OF VIRGINIA SHOWING SKYLINE DRIVE.** Millions of years old, the Blue Ridge Mountains are characterized by a blue mist. The rolling mountains seen today were once as jagged and craggy as the Himalayas. The rounded peaks of the Blue Ridge are a product of mechanical erosion (from the extreme forces of water and wind) and chemical erosion (from acid rain). (Courtesy of Asheville Post Card Company.)

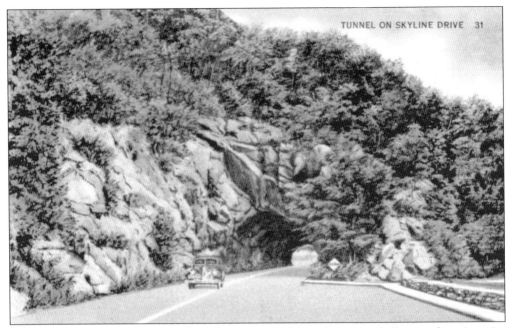

**TUNNEL ON SKYLINE DRIVE.** Tunnels were a special engineering challenge when America decided to focus on road improvements across the nation. Some were especially difficult when the scenic highways were being constructed. The engineers were asked to make as little of an impact on the environment as possible. (Courtesy of A. J. Simonpietri Jr.)

**SHENANDOAH VALLEY, LAND OF LUSCIOUS APPLES.** Many varieties of apples are grown in the Shenandoah Valley. There are so many that when apple trees start blooming, there is a continuous color of flowers for over one month. Winchester, Virginia, is host to one of the longest-running civic events in the state of Virginia—the Apple Blossom Festival. Starting in 1924, the festival has run yearly, only discontinuing for World War II. (Courtesy of A. J. Simonpietri Jr.)

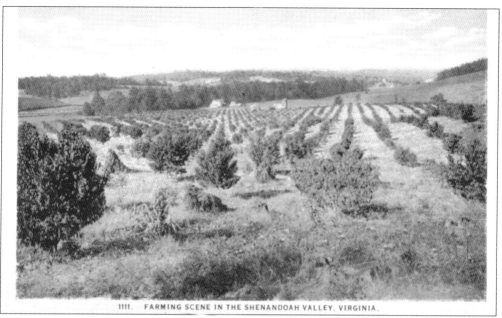

**FARMING SCENE IN THE SHENANDOAH VALLEY, VIRGINIA.** This colorized linen postcard was printed in the 1940s. An apple farm is depicted in a low valley near the Shenandoah National Park. Early American families relied upon apples for cash crops and for their personal use. They also had several different types of animals, including cattle, sheep, chickens, peacocks, and horses. (Courtesy of J. P. Bell Company.)

**APPLE BLOSSOMS.** This is a real-photo postcard (c. 1935) with a small white border. Apples were grown on the east side of the mountains because that side is less likely to develop frost that kills the bloom in the early spring. In addition, facing east gives the trees more sun during the day.

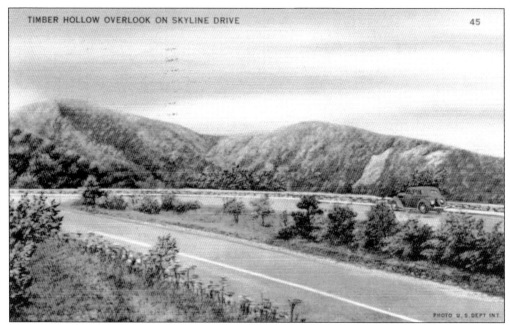

**TIMBER HOLLOW OVERLOOK ON SKYLINE DRIVE.** The photograph was taken by the U.S. Department of Interior *c.* 1944. Timber Hollow Overlook is located at milepost 39.7 and is also known as Hemlock Springs Overlook because the ridge on the right is a typical environment for natural hemlocks. A cement water reservoir below Hemlock Springs was constructed to provide water for Stony Mountain Overlook at milepost 38.6. (Courtesy of A. J. Simonpietri Jr.)

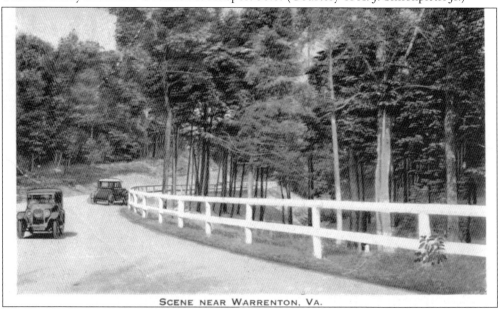

**SCENE NEAR WARRENTON, VA.** Warrenton is the county seat of Fauquier County, Virginia. Named after Joseph Warren, a Revolutionary War patriot with close ties to Paul Revere, Warrenton has had a rich history of nearly 200 years. Popular activities in Warrenton include fox hunting and horse racing. Quarter horses and walking horses were very popular breeds found in Virginia. (Courtesy of Eagle Post Card Company.)

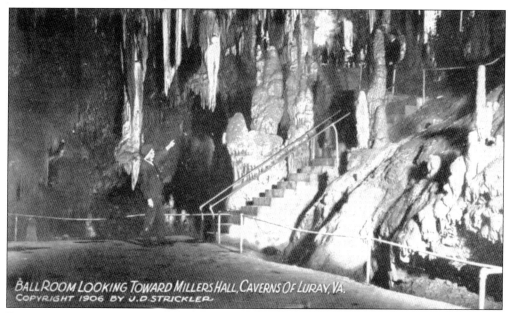

**BALLROOM LOOKING TOWARD MILLERS HALL.** This beautiful scene is a picture of an area within the Luray Caverns that exhibits fantastic stalactites and stalagmites. This postcard is a fine example of early black-and-white real-photo postcards that was printed for the early-20th-century American tourist industry. One fascinating feature found in the caverns of Luray is the organ that actually plays symphonic music when struck with an electronic hammer. It is the world's largest musical instrument. It was invented in 1954 by Leland Sprinkle of Springfield, Virginia. The stalactites have been tuned to a concert pitch. (Courtesy of Luray Caverns Corporation.)

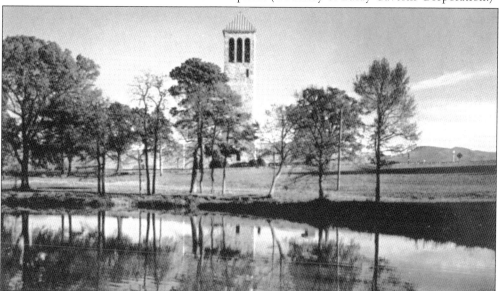

**SINGING TOWER.** The Singing Tower is located in Luray, Virginia. The tower sings from March through October through recitals conducted by Carillonneur David Breneman. He conducts recitals that last for almost an hour. The 23 bells from the carillon range in weight from 12.5 pounds to 7,640 pounds. Such sweet bell sounds are not found anywhere else in the country. (Courtesy of A. J. Simonpietri Jr.)

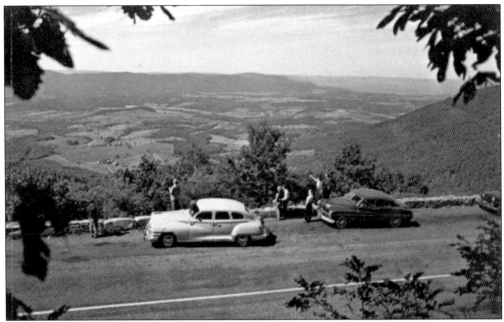

**PATCHWORK FIELDS OF THE BEAUTIFUL SHENANDOAH VALLEY.** Mountaintop pull-offs give way to patchwork quilt views along the Skyline Drive and the Blue Ridge Parkway. Crops of different types give way to the different colors and textures seen from above. (Courtesy of A. J. Simonpietri Jr.)

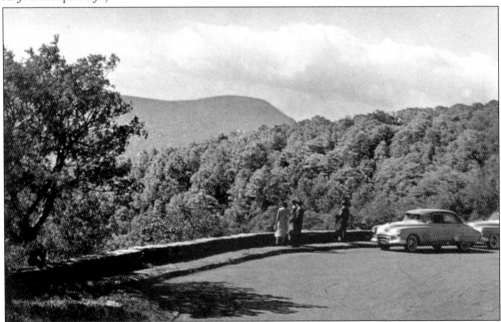

**AUTUMN ON STONY MAN MOUNTAIN.** This is a scene from an overlook on Skyline Drive in autumn. This real-photo postcard depicts the wonder and amazement that can be found on the Skyline Drive. Vibrant colors are produced when plants and trees go through a seasonal change. High rainfalls in the spring and summer create an even brighter fall. (Courtesy of A. J. Simonpietri Jr.)

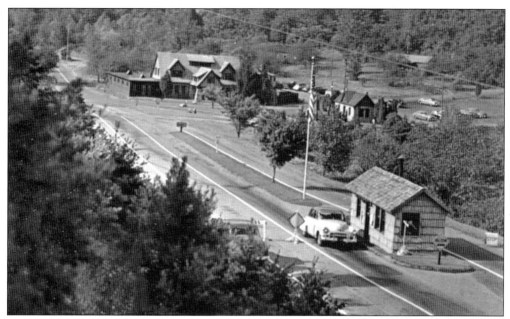

SKYLAND BY MOONLIGHT, NEAR SKYLINE DRIVE. Entrepreneur George Freeman Pollock, a Washington, D.C., native, established Skyland in the 1880s as a tent camp. Later log cottages were built as seen in this vintage linen card. Today Skyland is one of the main concession operations within the park. Wonderful trails take either the hiker or the horseback rider through beautiful nooks and crannies of the White Oak Canyon. (Courtesy of A. J. Simonpietri Jr.)

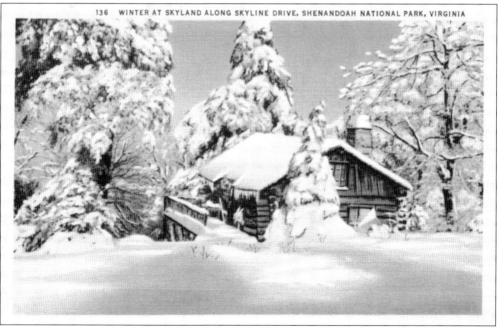

A PIONEER LOG CABIN IN THE SHENANDOAH NATIONAL PARK. Very atypical, this winter scene linen postcard depicts the very typical early American home of the average person. The logs were cut from poplar and notched to fit snugly together. The holes were plugged with mud and sod to keep the cold out and the heat in. (Courtesy of Marken and Bielfeld, Inc.)

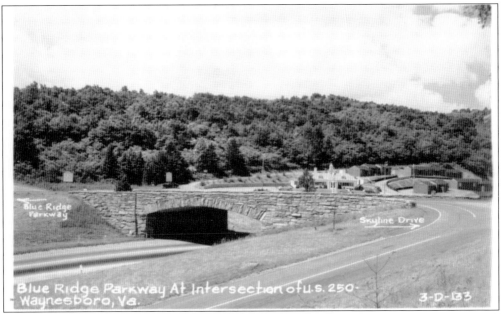

**BLUE RIDGE PARKWAY, WAYNESBORO, VA.** This beautiful black-and-white-era postcard shows the U.S. Highway 250 intersection in Waynesboro, Virginia. Here Skyline Drive ends and the Blue Ridge Parkway begins. This photograph was taken sometime in the mid-1930s. One could stop and pick up a snack, replenish the ice, or fill up with gas—a must when traveling the scenic route. (Courtesy of W. M. Cline.)

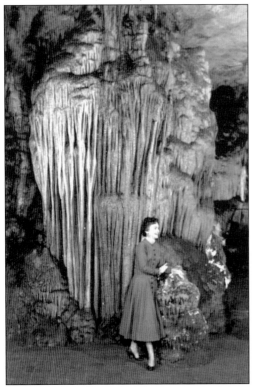

**LURAY CAVERNS.** By far the most popular caverns on the East Coast, Luray Caverns is located in Front Royal, Virginia, beneath the Shenandoah National Forest. Using only a rope and a candlestick, Andrew Campbell and Benton Stebbins discovered Luray Caverns in 1878. Luray Caverns is a series of caves linked together by narrow passageways. (Courtesy of Walter H. Miller.)

# Four

# The Great Smoky Mountains

*To every thing there is a season, and a time to every purpose under the heaven.*
—Ecclesiastes 3:1

At one time, the Great Smoky Mountains were ancient mountain ranges with tall and ragged peaks. Now weathered peaks and valleys remain.

In this chapter, the reader will discover the vast opportunities to see nature at its best through vintage postcards, especially winter scenes. Great photographers and artists have used the Smoky Mountains for their subject for many years. Some of the most popular postcards were created to sell the would-be visitor on the park. They were encouraged to buy the postcards for keepsakes of their vacation and to share them with family and friends.

At the turn of the century, logging was the main resource of the Smoky Mountains. Settlers found all of the good land bought by the logging companies.

After visiting the national parks in the western United States, Willis P. Davis and his wife, Ann Louella Patrick May Davis, of Knoxville, Tennessee, suggested that the East have a national park. It took 30 years for the project to be completed.

On June 15, 1934, the park officially came into existence. After the CCC built the roads and trails, Pres. Franklin D. Roosevelt dedicated the park on September 2, 1940, at Newfound Gap in the Rockefeller amphitheater. From the beginning, the federal government did not want to invest money in the park. The states of North Carolina and Tennessee began purchasing and donating land. John D. Rockefeller Jr. donated $5 million, which put the fund above all expectations.

Today over 10 million visitors come to the park each year. Most come to experience wilderness and wildlife.

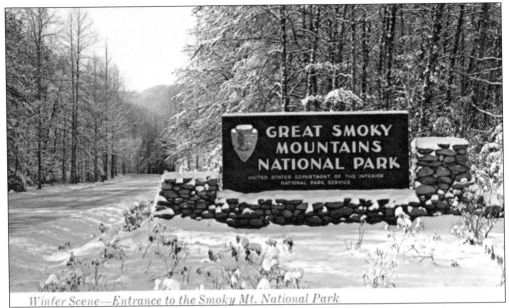

*Winter Scene—Entrance to the Smoky Mt. National Park*

**SNOWY ENTRANCE TO THE GREAT SMOKY MOUNTAINS NATIONAL PARK.** Days during the winter fickle season can be sunny and 70 degrees or snowy with highs in the 20s. In the low elevations, snows of one inch or more occur one to five times a year. At Newfound Gap, 69 inches fall on the average. Lows of 20 degrees below 0 are possible in the high country. (Courtesy of W. M. Cline.)

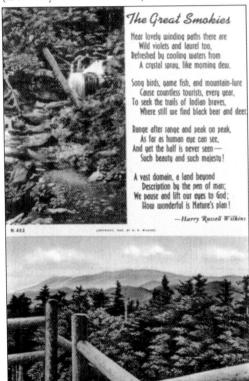

**THE GREAT SMOKY MOUNTAINS POEM BY HARRY RUSSELL WILKINS.** Poet Harry Russell Wilkins wrote many poems about the Smoky Mountains and mountain life. He captured in words what most capture in vision. This linen-era postcard has two scenes, one of a mountain stream and one of a distant view. (Courtesy of D. H. Ramsey Library, Special Collections, University of North Carolina at Asheville.)

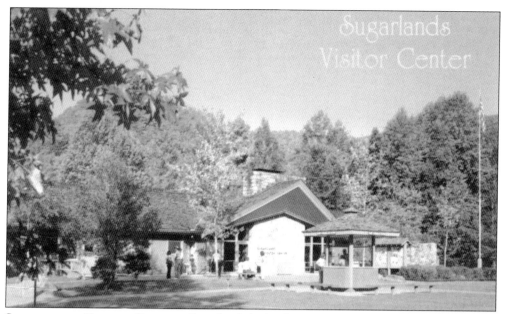

SUGARLANDS VISITOR CENTER. Sugarlands is the first visitor's center in the park from the Tennessee side. Located at the intersection of Newfound Gap and Little River Roads, the center offers publications, information, exhibits, and a film about the park. Sugarlands sits atop the campsite for the local CCC boys during the construction of the park. (Courtesy of Tennessee Postcard Company.)

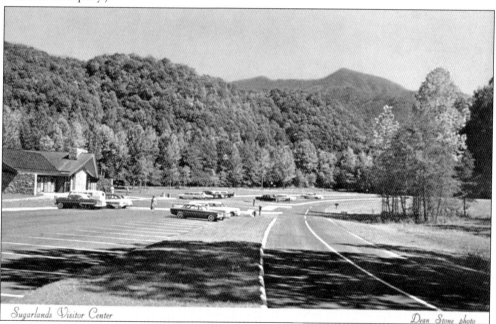

SUGARLANDS VISITOR CENTER IN THE 1960S. Natural history exhibits of the Great Smoky Mountains are featured at Sugarlands. The park headquarters are located on the grounds behind the visitor center. The center bears the name of the surrounding area covered by an abundance of maple trees, the sap of which provided sweetening for the pioneers. This chrome-era postcard is dated September 1975. (Courtesy of Stonecraft.)

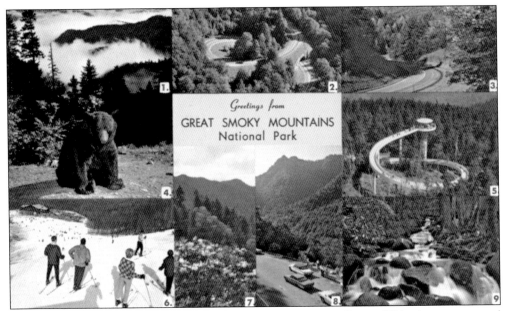

**GREETINGS FROM GREAT SMOKY MOUNTAINS NATIONAL PARK.** This chrome-era card was a great way for the visitor to keep memories all together. Numbered images are as follows: 1. above the clouds at sunrise, 2. the Loop-Over on 441, 3. fall colors in the Smokies, 4. black bear, 5. tower atop Clingman's Dome, 6. winter skiing scene, 7. rhododendron in bloom, 8. Chimney Tops, and 9. a mountain stream. (Courtesy of W. M. Cline.)

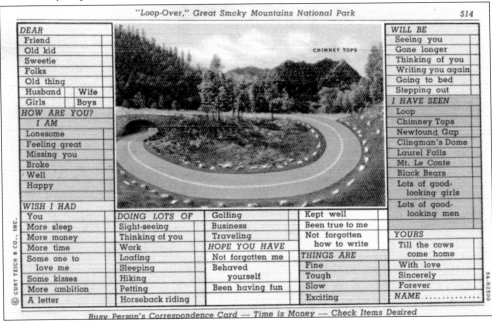

**BUSY PERSON'S CORRESPONDENCE CARD–TIME IS MONEY–CHECK ITEMS DESIRED.** This linen-era card is a great conversation piece. The writer simply checked off his greetings, addressed the card, and dropped it in the mail. This style dates to the late 1930s and early 1940s. This particular one has a photograph of the Loop-Over on Highway 441, with the Chimney Tops in the background. (Courtesy of Curt Teich and Company, Inc.)

**CHIMNEY TOPS IN THE GREAT SMOKY MOUNTAINS.** The Chimney Tops trail boasts an elevation gain of 1,335 feet. This is one of the most popular hikes in the Smoky Mountains. By the end of the hike, most people are using their hands and feet to gain access to the top. (Courtesy of Asheville Post Card Company.)

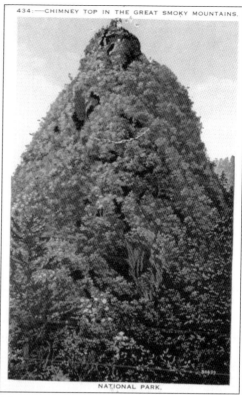

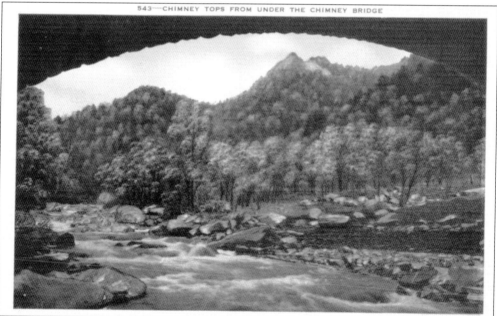

**CHIMNEY TOPS FROM UNDER THE CHIMNEY BRIDGE.** The wide arch of the beautiful masonry bridge across the west prong of Little Pigeon River at the entrance to the Chimney's Camp Ground forms a quaint frame for a view of the Chimney Tops. Hand chiseled, these stone bridges stand today as a testament to the skill of the CCC. (Courtesy of Standard News Agency.)

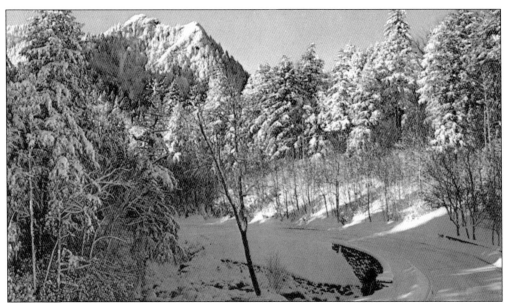

CHIMNEY TOPS IN WINTER, GREAT SMOKY MOUNTAINS NATIONAL PARK. Visiting the Chimney Tops is a four-mile round-trip hike that has changes in elevation over 1,300 feet. They are a natural geological formation of rocks that was formed thousands of years ago and are among native virgin forest. The Chimney Tops are two prominent knobs underlain by dark slate-type rocks of the Anakeesta Formation at about 4,700 feet above sea level. (Courtesy of W. M. Cline.)

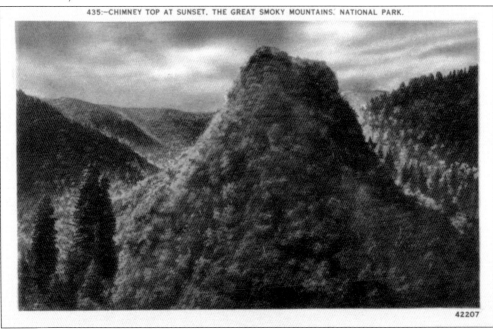

CHIMNEY TOPS AT SUNSET. Sunset in the mountains on a clear day is glorious with colors of blue, pink, orange, and yellow. In this linen-era postcard, the sun is setting over the Chimney Tops. The Chimney Tops can be reached from a trailhead that starts off of 441, the Newfound Gap Highway, on the Gatlinburg side. (Courtesy of Asheville Post Card Company.)

**HIKERS VIEWING THE CHIMNEY TOPS.** One trailhead for the Chimney Tops begins in the picnic area along a mountain stream. Large boulders fill the stream, bringing temptation to the young and old to skip and explore. From the beginning of the park in the early 1930s, tourists were encouraged to bring a lunch and snack so that they could enjoy the great outdoors as in this linen-era postcard. (Courtesy of Asheville Post Card Company.)

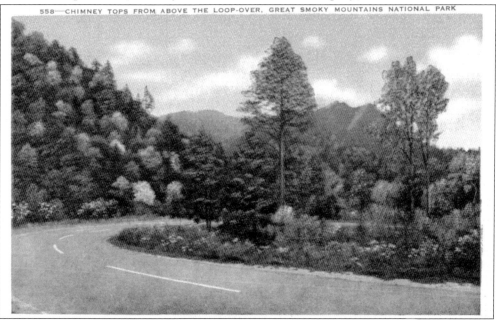

**CHIMNEY TOPS ABOVE THE LOOP-OVER.** The peaks are so tall on the Chimney Tops that many different views have been painted and photographed. They can be seen for miles and miles and dominate the view from the Tennessee side of the Newfound Gap Highway, particularly from the Loop-Over. (Courtesy of Standard Souvenir and Novelties, Inc.)

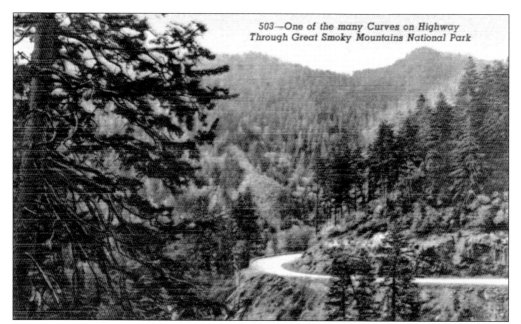

**ONE OF THE MANY CURVES ON HIGHWAY THROUGH GREAT SMOKY MOUNTAINS NATIONAL PARK.** This linen-era postcard from 1952 was mailed to Cape Cod, Massachusetts, from Cashiers, North Carolina. It shows one of the many wide, sweeping curves that afford comfortable and safe motoring in all seasons of the year. (Courtesy of Curt Teich and Company, Inc.)

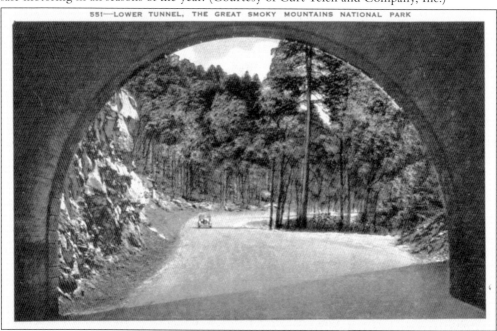

**LOWER TUNNEL ON NEWFOUND GAP HIGHWAY.** This 1930s linen-era postcard shows a Model T getting ready to go through the lower tunnel on Newfound Gap Highway. Tunnels were a spectacular engineering feature of the National Park System during Roosevelt's New Deal era. They used big tonnage trucks and built scaffolding on the bed of the truck to chisel rock out of the mountainside. (Courtesy of Standard Souvenir and Novelties, Inc.)

**UPPER TUNNEL ON U.S. 441 NEAR NEWFOUND GAP.** W. M. Cline made this photograph of the upper tunnel during the month of June showing rhododendron in full bloom above the tunnel. Today, before entering the tunnel, drivers are told to turn their headlights on and to remove their sunglasses for better visibility. (Courtesy of W. M. Cline.)

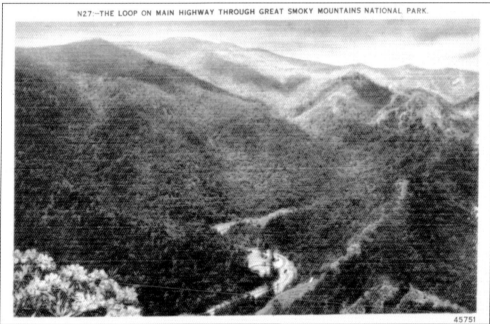

**THE LOOP ON NEWFOUND GAP HIGHWAY.** The Loop-Over is one of the most unique features created by the CCC. Here the road makes one complete circle instead of four sharp curves that were on the old road at this point. From the Loop can be seen the famous Chimney Tops, which is one of the most rugged and picturesque peaks of the Great Smoky Mountains. (Courtesy of Asheville Post Card Company.)

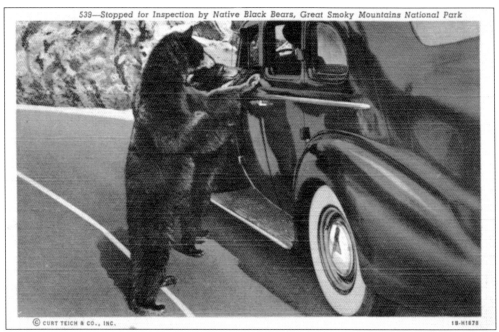

**DON'T FEED THE BEARS.** These delightful little creatures stopped a passing car for inspection along Newfound Gap Highway. Bears may be found wandering along the highway or climbing trees and add pleasure to the visitor viewing the scenic beauty of the mountains. Visitors from all over the world visit just to see the bears. (Courtesy of Curt Teich and Company, Inc.)

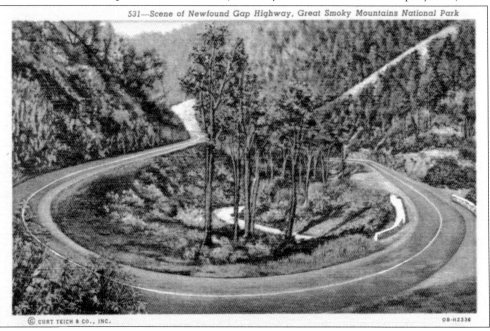

**SCENE ON THE NEWFOUND GAP HIGHWAY.** This is but one of the many "S" curves found along Newfound Gap. They add character and different views to this once-treacherous wilderness. One moment the view is on the right, and the next moment the view is on the left. (Courtesy of Curt Teich and Company, Inc.)

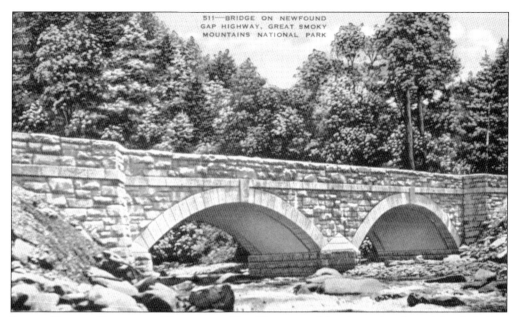

**STONE BRIDGE FOUND ON NEWFOUND GAP HIGHWAY.** Here is a springtime view of a bridge made of masonry fitting into the landscape of the surrounding mountains. This double-arch bridge spans the west prong of the Little Pigeon River. Inviting cool waters tempt the summer visitor to take their shoes off and go wading in the mountain stream. (Courtesy of Standard News Agency.)

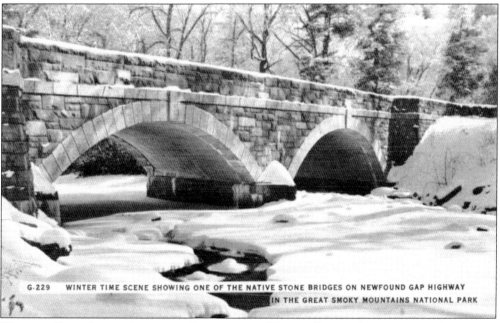

**WINTER TIME SCENE SHOWING ONE OF THE NATIVE STONE BRIDGES ON NEWFOUND GAP HIGHWAY.** What an enchanting vision this is. It is ironic that the sender of this card chose a winter scene because she talks about being "so darn sun burned" even though it was not very hot on her vacation. This linen-era postcard looks to be from the very early 1930s. (Courtesy of Asheville Post Card Company.)

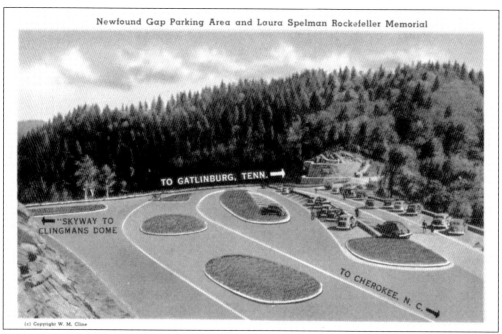

**NEWFOUND GAP PARKING AREA AND LAURA SPELMAN ROCKEFELLER MEMORIAL.** This linen-era postcard created by W. M. Cline in the late 1930s is labeled with the highlights of Newfound Gap. (Courtesy of W. M. Cline.)

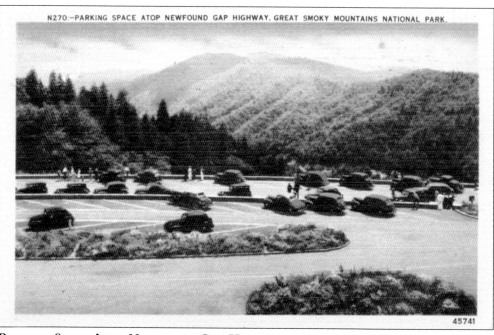

**PARKING SPACE ATOP NEWFOUND GAP HIGHWAY IN THE MID-1930S.** This parking lot atop Newfound Gap is hardly ever empty. Tourists traveling from either side of the mountain stop to take in the view. The Tennessee and North Carolina state line crosses this ridge as does the Appalachian Trail. (Courtesy of Asheville Post Card Company.)

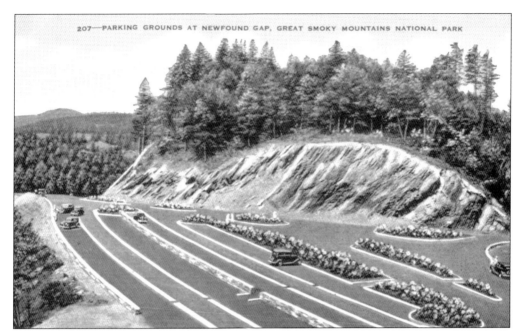

**SPRING TIME ATOP NEWFOUND GAP HIGHWAY.** There is ample room for several hundred cars to park in this gap, 5,045 feet above sea level. A splendid view of the mountains can be seen from here. Newfound Gap is the lowest drivable pass through the Great Smoky Mountains. Newfound Gap's recognition as the lowest pass through the Smoky Mountains did not come until 1872. (Courtesy of Standard News Agency.)

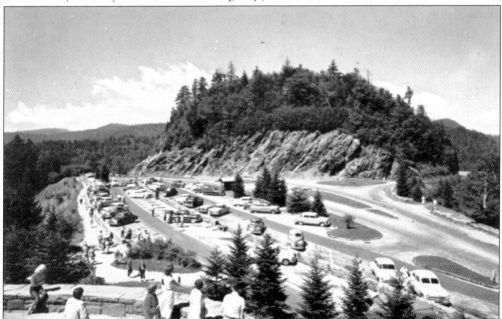

**VIEW ATOP NEWFOUND GAP OF THE PARKING AREA, 1955.** W. M. Cline revisited the Newfound Gap parking area to get this great view in 1955. It is the highest point on the transmountain highway between Tennessee and North Carolina. To the left in this chrome-era postcard can be seen Clingman's Dome, the highest peak in the park. (Courtesy of W. M. Cline.)

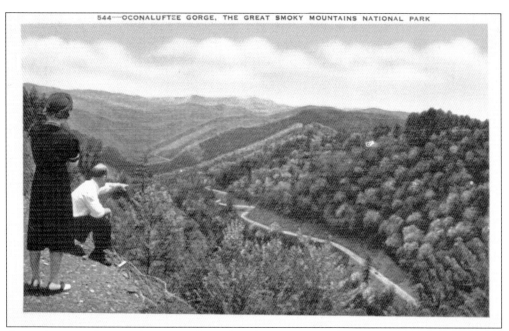

OCONALUFTEE GORGE. Just west of Newfound Gap, we get a fine view of the North Carolina side of the Newfound Highway as it winds its way down the Oconaluftee Gorge. This 1940s linen-era card shows a couple taking in the sights. Lots of honeymooners start their lives together in the Smoky Mountains. (Courtesy of Standard News Agency.)

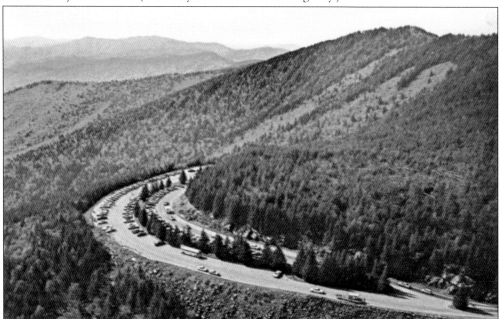

AERIAL VIEW OF THE OVERLOOK AT CLINGMAN'S DOME. From an elevation of 6,311 feet, the visitor here has a wide range of scenic views into North Carolina in this chrome-era postcard taken in 1969. A fine, half-mile paved trail leads straight up to a modern observation tower on the summit of Clingman's Dome, the highest point in the Great Smoky Mountains National Park, which is 6,642 feet above sea level. (Courtesy of W. M. Cline.)

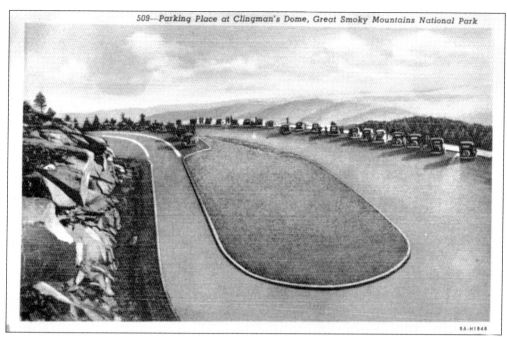

**PARKING PLACE AT CLINGMAN'S DOME.** This linen-era card represents a clear day at Clingman's Dome. On a clear day, one can see many miles into the surrounding forest and vistas. On a cloudy day, one sees the inside of a cloud and feels the cool mist of the rain. Fickle is the weather atop Clingman's Dome. Travelers should beware. (Courtesy of Curt Teich and Company, Inc.)

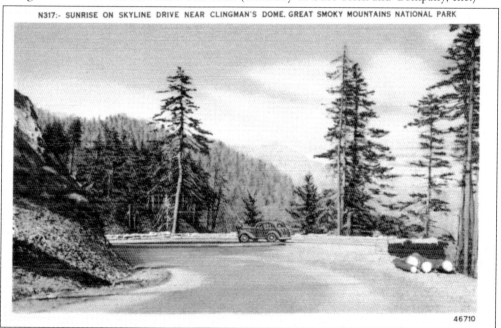

**SUNRISE ON SKYLINE DRIVE NEAR CLINGMAN'S DOME.** Along the eight-mile drive from Newfound Gap to Clingman's Dome are some pullovers with beautiful views of the valley floor below. A spectacular sunrise is seen in this linen-era postcard. (Courtesy of Asheville Post Card Company.)

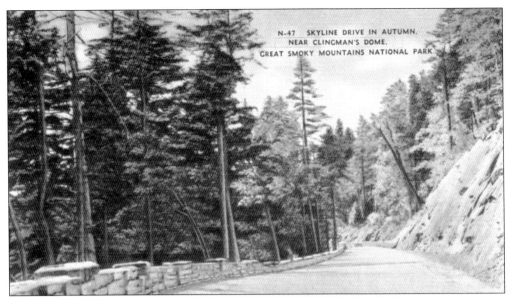

SKYLINE DRIVE IN AUTUMN NEAR CLINGMAN'S DOME. One of the greatest of nature's displays is the Great Smoky Mountains National Park, the largest national park in eastern America. The park straddles the high ridge of the Great Smoky Mountain range, which forms the boundary between North Carolina and Tennessee. Within its borders, there are many mountain peaks over a mile high, deep ravines, precipitous cliffs, waterfalls, and numerous mountain streams. (Courtesy of Asheville Post Card Company.)

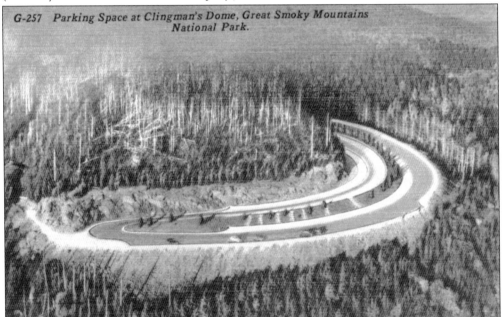

PARKING SPACE AT CLINGMAN'S DOME. The mountain was named after the Civil War general and U.S. senator Thomas Lanier Clingman, a prospector who obtained much wealth from the timber and minerals of this region from Yadkin County, North Carolina. Clingman originally measured Mount Mitchell as the highest peak, which is at an elevation of 6,684. (Courtesy of Asheville Post Card Company.)

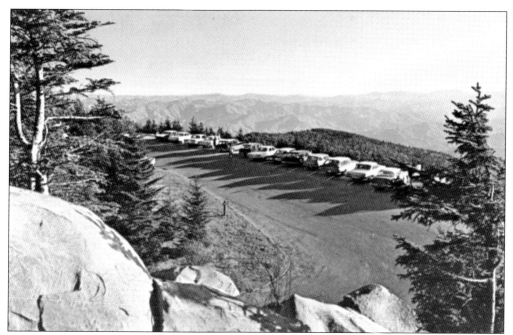

**CLINGMAN'S OVERLOOK.** This was named for Thomas L. Clingman (1812–1897), who was responsible for the first trail from Indian Gap to Clingman's Dome in the 1850s. Seen in this 1964 chrome-era postcard is the parking area. From this area of the parking lot, a mile trail leads to an observation tower on the summit. (Courtesy of W. M. Cline.)

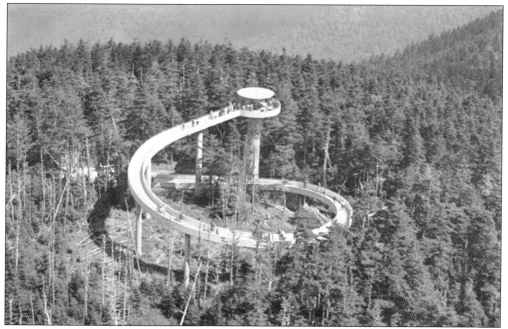

**OBSERVATION TOWER ATOP CLINGMAN'S DOME.** This 1962 chrome-era postcard shows the observation tower located atop Clingman's Dome. From this modern tower, magnificent views may be had in all directions looking into North Carolina and into Tennessee. This is one of the most popular points of interest in the national park. (Courtesy of W. M. Cline.)

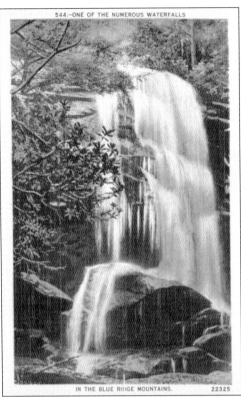

ONE OF THE NUMEROUS WATERFALLS. Forty percent of the Smoky Mountains National Forest is in Swain County, North Carolina, including Clingman's Dome and several waterfalls. This linen-era postcard looks like Juneywhank Falls, located near Bryson City. It was probably named after a local, Chief Junaluska Whank. Legend has it that he is buried close by the falls. (Courtesy of Asheville Post Card Company.)

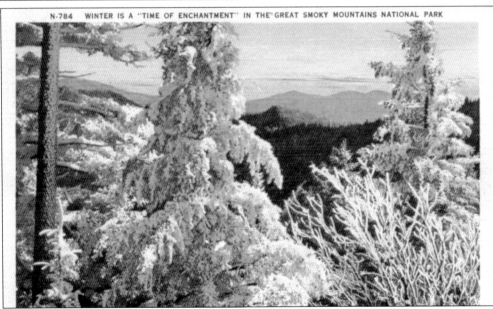

WINTER "ENCHANTMENT" IN THE SMOKY MOUNTAINS. One of the greatest of nature's displays is the Great Smoky Mountains covered in a blanket of snow. The very unpredictable weather in the higher elevations can create snow in the winter while the valleys are dry. As seen in this 1930s linen-era postcard, a lot of the snow is wet snow and very heavy, causing the branches to lean from the weight. (Courtesy of Asheville Post Card Company.)

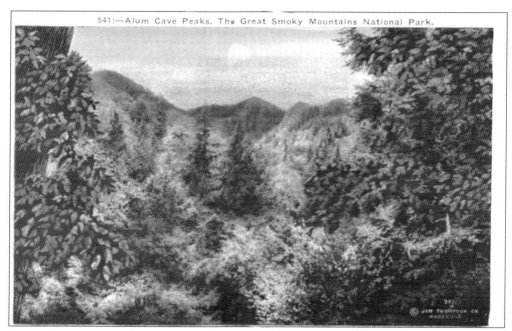

**ALUM CAVE PEAKS.** Alum Cave is not what the name implies. It is not a cave—rather it's a jutting ledge of black slate forming out over the trail to give the impression of a cave. The name Alum Cave comes from the deposits of alum found along the "cave" walls. In 1925, a lodge was built on top of Mount Le Conte near Alum Cave. (Courtesy of Asheville Post Card Company.)

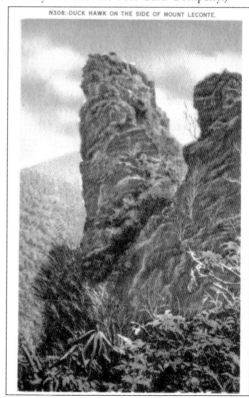

**DUCK HAWK ON THE SIDE OF MOUNT LE CONTE.** Near the Alum Cave Bluff on the south side of majestic Mount Le Conte is the thin leaning ridge with jagged points known as Duck Hawk Peaks. Under the left side of the over-hanging on this spectacular point, a pair of duck hawks, a favorite falcon, has nested for many years. Through these narrow ridges are holes or windows. (Courtesy of Asheville Post Card Company.)

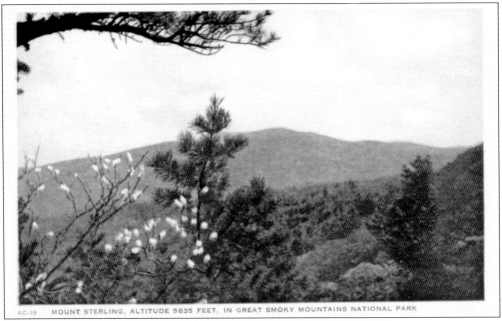

**MOUNT STERLING GAP TRAIL.** This low ridge trail begins at Mount Sterling Gap on Cataloochee–Big Creek Road. It is rated extremely strenuous because of a 2,000-foot climb in 2.3 miles along an old jeep trail to a ridge a half-mile below the Mount Sterling Firetower. This is an early chrome-era postcard with blue sky. (Courtesy of Asheville Post Card Company.)

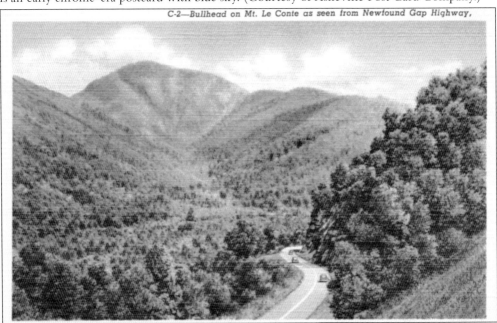

**BULLHEAD ON MT. LE CONTE AS SEEN FROM NEWFOUND GAP HIGHWAY.** From the Tennessee side of Newfound Gap Highway, we see Bullhead, a spur of Mount Le Conte, on the left. The Bullhead trail is one of the more popular trails of Mount Le Conte that starts from Cherokee Orchard road. This trail is for those that feel guilty about the Pancake House breakfast buffet. (Courtesy of Curt Teich and Company, Inc.)

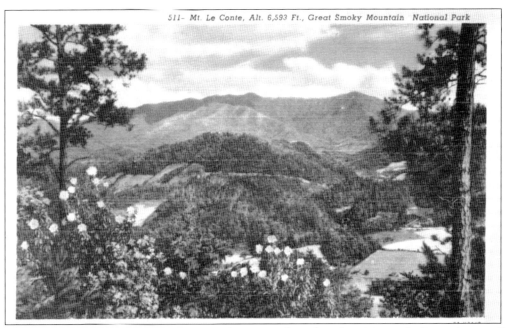

**Mt. Le Conte, Alt. 6,593 Feet.** With a 6,593-foot elevation, Mount LeConte is one of the Great Smoky Mountains National Park's highest peaks. When the movement to establish a national park in the Smokies was in full sway, a tent camp was erected where LeConte Lodge now stands to entertain visiting dignitaries from Washington. (Courtesy of Curt Teich and Company, Inc.)

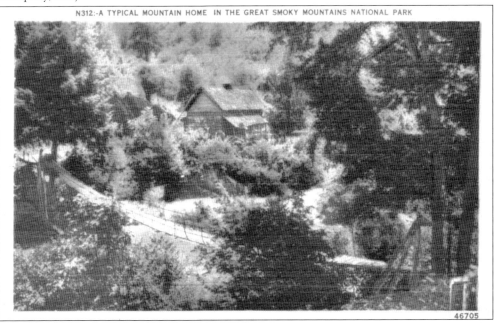

**A Typical Mountain Home.** Early Americans built their labor-intensive homes out of logs that were squared so that one log could lay against another with minimal chinking. The foundation and chimney were made of rock. Chimneys were commonly placed in the center of the home, as seen in this vintage linen-era postcard. (Courtesy of Asheville Post Card Company.)

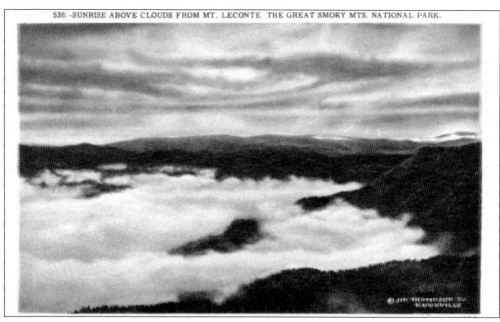

**SUNRISE AND CLOUDS ABOVE MT. LE CONTE.** The Smoky Mountains get their name from the clouds and fog that envelop the mountains. This comes from high humidity and the gases put off by the plants. Trees are known to release 600 gallons of water a day in this region, giving it a hazy, misty look. This linen-era postcard was created by Jim Thompson of Knoxville in the 1940s. (Courtesy of Asheville Post Card Company.)

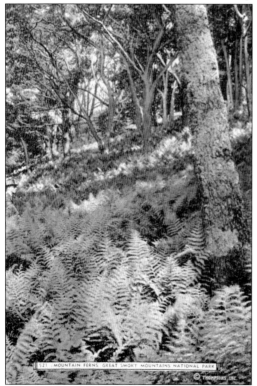

**MOUNTAIN FERNS.** While this particular bed of hay-scented ferns is found along the trail to Gregory Bald, these lacy waist-high beauties grow in great abundance on the many peaks of the Great Smokies. These mountains contain the world's greatest variety of plant life. It has the largest remaining tracts of old growth forest in the eastern United States. (Courtesy of Standard News Agency.)

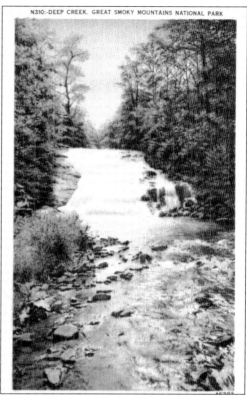

**DEEP CREEK FALLS.** Two waterfalls exist on Deep Creek—Tom's Branch Falls and Indian Creek Falls. The road trail parallels the creek. A full day of entertainment can be enjoyed from tubing this scenic area. This vintage linen-era postcard is of Indian Creek Falls. They are noisy and boisterous high-volume cascades that plunge 25 feet into a large inviting pool base. Rhododendron and other vegetation surround the falls. (Courtesy of Asheville Post Card Company.)

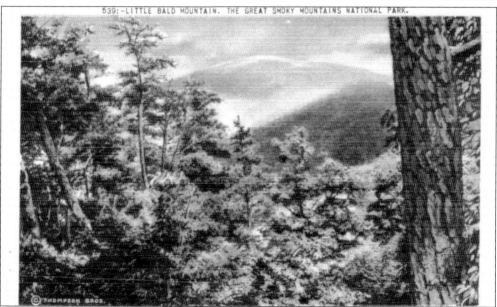

**LITTLE BALD MOUNTAIN.** This linen-era postcard was created by the Thompson Brothers in the late 1930s or early 1940s. In 1973, a trail was developed called the "Mountains to Sea Trail" that covers almost 1,000 miles. It begins at Clingman's Dome and ends at Jockey's Ridge State Park on the Atlantic Ocean. Little Bald Mountain is but one of the mountains that it passes over. (Courtesy of Asheville Post Card Company.)

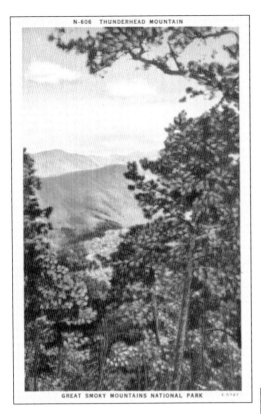

**THUNDERHEAD MOUNTAIN.** Thunderhead Mountain is over 5,500 feet and can be reached from the Appalachian Trail. Framed views are numerous along trails in the Smokies, like the one in this linen-era postcard. The trail winds through boulders and patchy grasslands with a limited amount of tree foliage. (Courtesy of Asheville Post Card Company.)

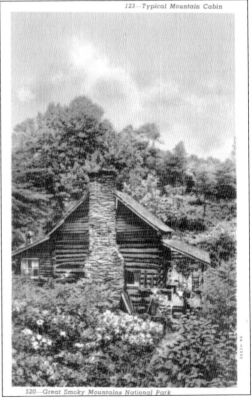

**TYPICAL MOUNTAIN CABIN.** Here is another mountain cabin with a front porch and a room added on the back. As families of early America grew, so did their homes. One by one they added more rooms as time allowed. Some had lofts for extra sleeping room. (Courtesy of Curt Teich and Company, Inc.)

SMOKEMONT STORE, SMOKEMONT, NORTH CAROLINA. Before tourism, lumber was the prime business in the Blue Ridge and Great Smoky Mountains. Here in this rare photograph is the company store for Smokemont, a lumber camp. This community no longer exists. Again we see the foresight that Walter M. Cline had about this great park. (Courtesy of W. M. Cline.)

BLACK BEARS. Black bears are a frequent sight for tourists visiting the Great Smoky Mountains. They are very inquisitive and love to climb trees and mountainsides. This linen-era postcard is dated sometime in the 1930s, when feeding the bears became very popular with unrealized danger. (Courtesy of Curt Teich and Company, Inc.)

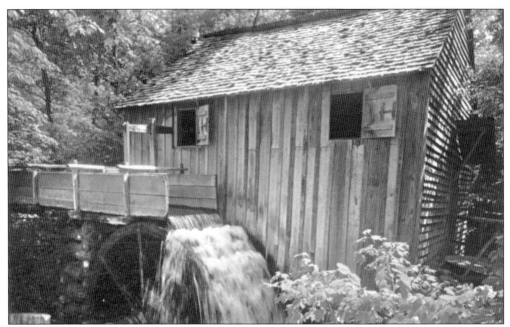

JOHN P. CABLE MILL. Located in the Cades Cove Section, the only gristmill left in the park using an overshot wheel is this one that John P. Cable built. It is operated from May to late October at a demonstration by the Great Smoky Mountains Historical Association. (Courtesy of Buckhorn Press.)

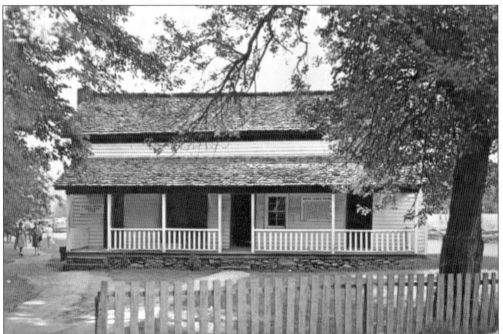

BECKY CABLE HOUSE, CADES COVE. The first frame house in Cades Cove was built by John P. Cable. He also built Cables Mill. A general store was operated in the building for many years. Becky Cable lived here until her death in 1940 at the age of 96. As you see in this chrome-era postcard, not much has changed since John Cable first built here. (Courtesy of W. M. Cline.)

**HIGHWAY BETWEEN ELKMONT AND GATLINBURG.** The drive between Elkmont Campground and Gatlinburg is one of the most traveled roads in the Smoky Mountains. It is the main park highway that links the Sugarlands Visitor Center, Elkmont, Townsend, and Cades Cove. This scenic linen-era postcard shows pastoral lands that were bought by the National Park Service before the 1930s. (Courtesy of Asheville Post Card Company.)

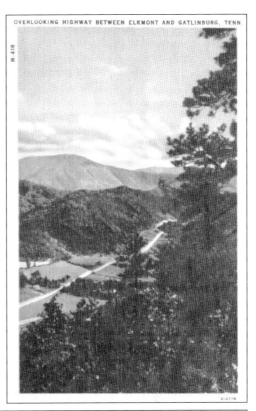

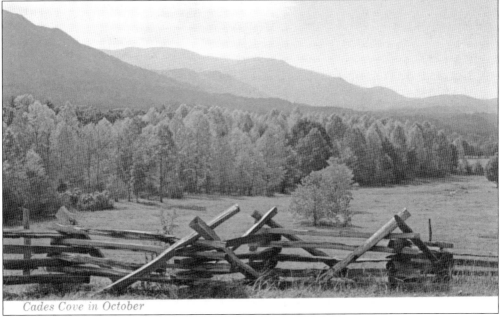

**CADES COVE IN OCTOBER.** Of the 10 million people that visit the Smokies each year, 2.5 million visit Cades Cove. If it were a national park by itself, it would still be one of the top-10 visited national parks in America. Cades Cove is 5,000 acres located in a valley circled by the mountains, seen in this chrome-era card from the 1960s. (Courtesy of W. M. Cline.)

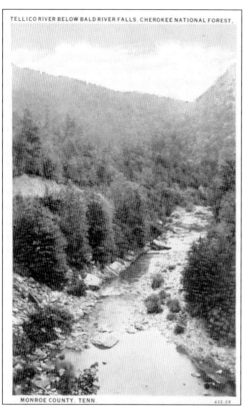

**TELLICO RIVER BELOW BALD RIVER FALLS, CHEROKEE NATIONAL FOREST.** This very detailed 1932 blue-sky-era postcard is of the Tellico River. The Bald River Falls descend over 100 feet before entering the river. By kayak, this river isn't for beginners. The river is very rocky and has several rapids. (Courtesy of Asheville Post Card Company.)

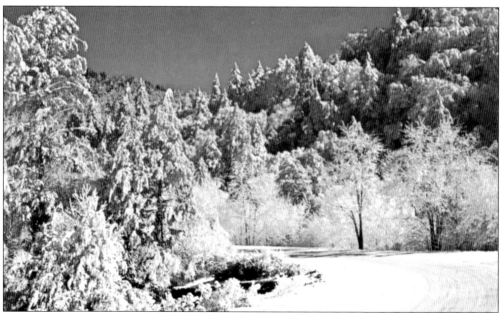

**WINTER IN THE SMOKIES BY DEAN STONE.** Winter brings a different type of beauty to higher elevations of the Great Smoky Mountains National Park. Snow and hoar frost (frozen fog) cover trees at Loop-Over on U.S. 441 near the Chimney Tops. Dean Stone photographed this chrome-era card scene after a snowstorm in the late 1960s. (Courtesy of Stonecraft.)

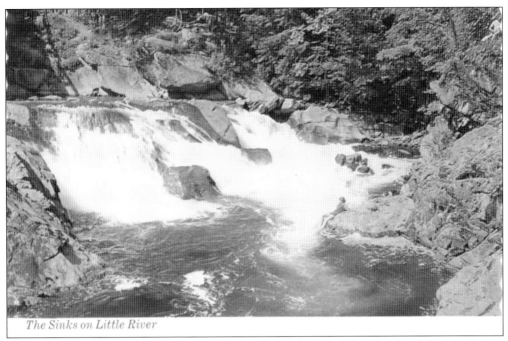

*The Sinks on Little River*

**THE SINKS ON THE LITTLE RIVER.** Located on 441 between the Sugarlands Visitor Center and the Townsend exit is the Sinks Falls. They have several tiers that run under the highway and can be missed by the passerby. The sinks are very popular for waders and picnickers alike. They are very powerful, as you see in this 1960s chrome-era postcard. (Courtesy of W. M. Cline.)

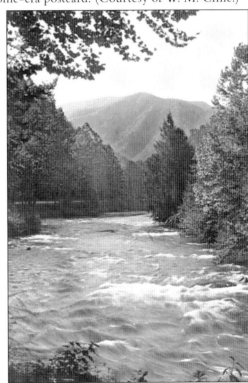

**NANTAHALA RIVER, WESTERN NORTH CAROLINA.** In 1959, Walter M. Cline took this chrome-era postcard photograph of the Nantahala River. It runs through the Nantahala Gorge in Western North Carolina. This is a very popular vacation spot today as it was 70 years ago. Camping and white water rafting are activities found in this area. (Courtesy of W. M. Cline.)

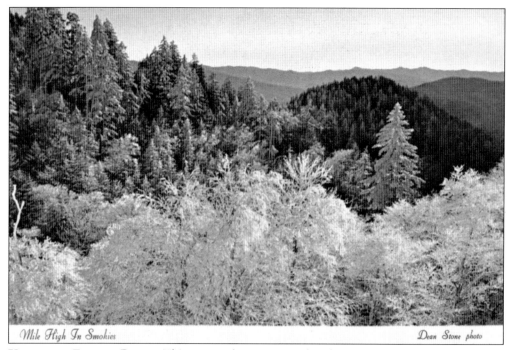

**VIEW FROM FORNEY RIDGE.** This spectacular view was taken from Forney Ridge and Mile High Road. Forney Ridge is a link between the Clingman's Dome parking area and Andrews Bald, a popular day-hike destination. The trail is rocky, and at some points, it follows the mountain ridge line. (Courtesy of Stonecraft.)

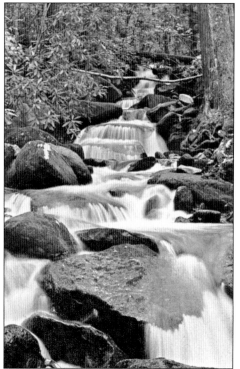

**LE CONTE CREEK BELOW RAINBOW FALLS.** One of the most rewarding hikes in the Smokies includes this one past a mountain stream below Rainbow Falls. This trail is 6.75 miles one-way and goes through treacherous gullies and rocks. The trail gains 4,017 feet and passes Rainbow Falls, which has an 80-foot waterfall. Since this chrome-era card was photographed in the 1960s, very little has changed. (Courtesy of W. M. Cline.)

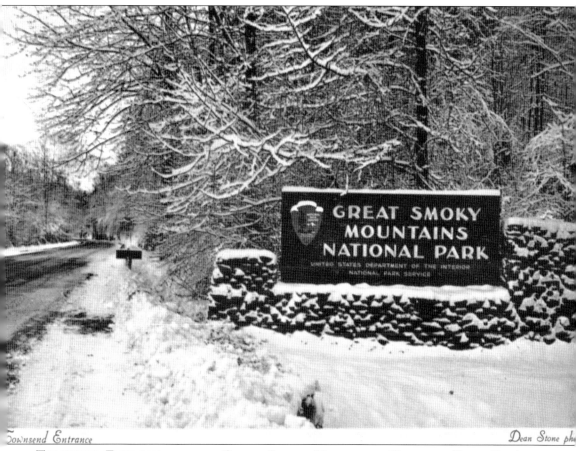

**TOWNSEND ENTRANCE TO THE GREAT SMOKY MOUNTAINS NATIONAL PARK.** During winter's snow, when spring's flowers bloom bright orange and pink, amid summer's fern greenery, or when fall's maple colors are blazing, Little River Gorge is perhaps the most beautiful drive in the Great Smoky Mountains. The park's western entrance at Townsend, Tennessee, is by Highway 73 along Little River Gorge. (Courtesy of Stonecraft.)

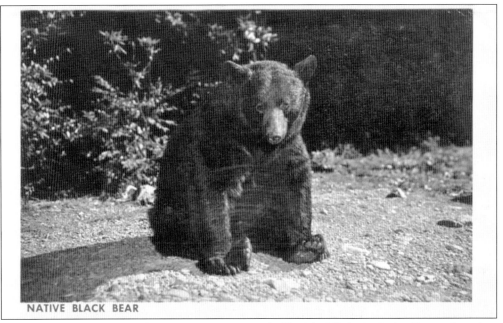

**NATIVE BLACK BEAR.** Today, as in 1956, visitors shrill with delight in Cades Cove when they sight native wildlife. (Courtesy of W. M. Cline.)

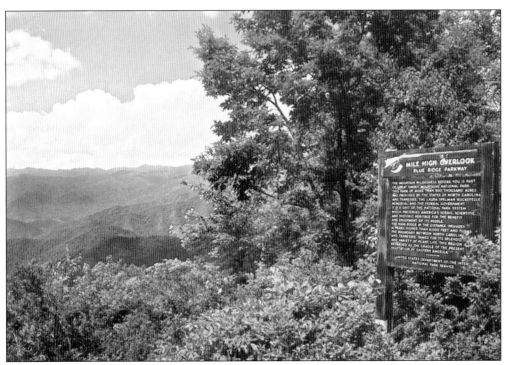

**MILE HIGH OVERLOOK.** This overlook is a short distance from Soco Gap in the Heintooga Overlook Road. The range in the distance is the Great Smoky Mountains. White-border chrome-era postcards came into production sometime in the early 1970s. This particular postcard has a nice crisp quality not always found in the chrome-era cards. (Courtesy of W. M. Cline.)

# Five

# The Eastern Cherokee Nation

*When I shall sleep in forgetfulness, I hope my bones will not be deserted by you.*
—Womankiller, of Hickory Log District, at more than 80 years of age

They called themselves Ani-Yun-Wiya, the Principle People. Their neighbors, the Muskigean, called them Tciloki, "people of different speech."

In this chapter, the reader will learn about the culture and beauty of the Cherokee. Archaeological studies have found evidence that suggest that they were in the Southeast several thousand years before the Europeans arrived.

The election of Andrew Jackson as president spelled the end for the Cherokee as they were. On December 29, 1835, Jackson convinced a handful of cooperative Cherokees to sign the infamous Treaty of New Echota, which gave them 12 million acres in Oklahoma in return for all of the Cherokee lands and a pledge to leave the mountains peacefully. Many refused to leave and the standoff ensued.

In 1838, almost the entire U.S. Army occupied Cherokee territory. Most Cherokee would march to Oklahoma, a journey known as the Trail of Tears. Sixteen thousand left, and a few hundred hid out in the mountains of North Carolina, Tennessee, Virginia, and South Carolina. Between 4,000 and 6,000 died before reaching Oklahoma.

In 1900, timber was the main source of income for the eastern band of the Cherokee. Most of the good timber had been sold. The government wanted to make Cherokee a great tourist site, but the Cherokee resisted this idea and began selling their crafts. Today Cherokee, North Carolina, is a popular attraction for tourists from around the world. The Totem Pole Gift shop in Cherokee, North Carolina, is the oldest gift shop in town and is still in business.

Thanks to Chief Jarrett Blythe, principal chief of the North Carolina Cherokees from 1939 to 1947, the path of the Blue Ridge Parkway was diverted to the mountaintops and ridges at the entrance to the Eastern Cherokee Nation. The decision was made after several years of deliberation.

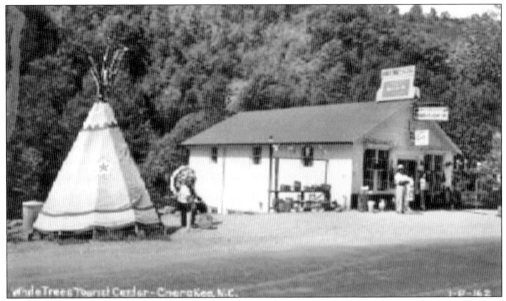

**WHITE TREES TOURIST CENTER, CHEROKEE, N.C.** Children and adults alike are delighted with teepees and chiefs to greet them as they tour the craft shops of the Cherokee. The Cherokee mastered entrepreneurship. This early black-and-white-era postcard was taken by W. M. Cline sometime in the 1940s. (Courtesy of W. M. Cline.)

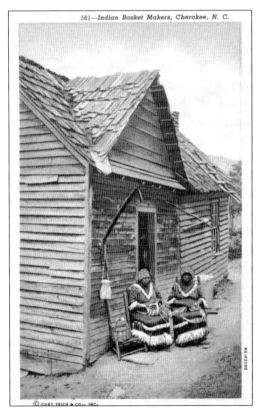

**INDIAN BASKET MAKERS, CHEROKEE, N.C.** Chief Standing Deer's wife and daughter are shown here making baskets in front of their home. Baskets of different colored wood are made by the Cherokee and sold in their craft shops. This is a talent many centuries old. Notice the clapboard house. The Cherokee lived in wooden homes even before the influence of the European settlers. (Courtesy of Curt Teich and Company, Inc.)

**Two Attractive Cherokee Maidens in Native Costumes.** The Cherokee native dress is made with hides and beadwork, as shown in this linen-era card. The Cherokee ladies are well known for their exquisite beading. They make belts, jewelry, and clothing with tiny beads that can be bought at different merchants on Main Street. (Courtesy of Asheville Post Card Company.)

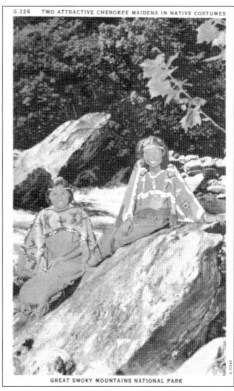

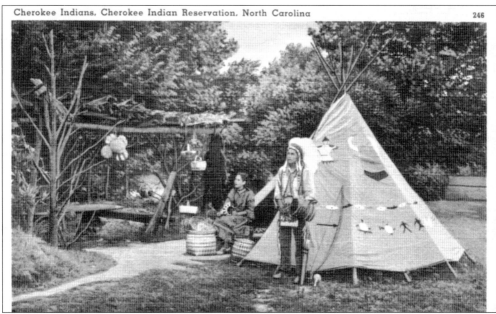

**Cherokee Indians, Cherokee, North Carolina.** The Cherokee today number many thousand on the reservation. They are descendants of those who hid in the Smokies when the removal to Oklahoma began in 1838. The Cherokee typically did not live in teepees. They lived in homes built with bark and wood and eventually cabins like the European settlers. (Courtesy of W. M. Cline.)

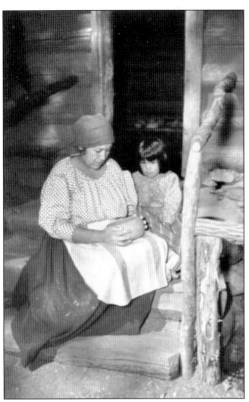

**CHEROKEE INDIAN MAKING POTTERY.** Pottery making on the Cherokee Indian Reservation is another centuries-old talent. They made bowls, urns, vases, and other useful clay creations as shown in this chrome-era postcard. Pottery became a trading tool for other goods needed in the villages during the 18th and 19th centuries. (Courtesy of Asheville Post Card Company.)

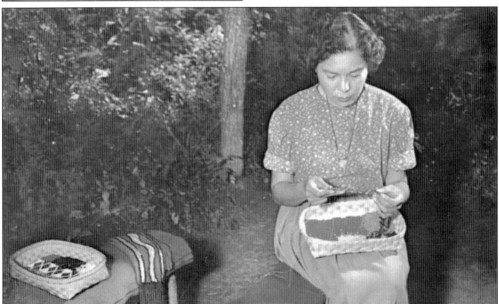

**ONE OF THE SKILLED BEAD WORKERS AT OCONALUFTEE INDIAN VILLAGE, CHEROKEE, N.C.** The Cherokee Indian bead workers are reviving an ancient art, as their ancestors did 200 years ago. The village is a living history project and is open from May through October. Demonstrations of canoe making, daily living, pottery making, blow gun making, and bead making can be seen. (Courtesy of Asheville Post Card Company.)

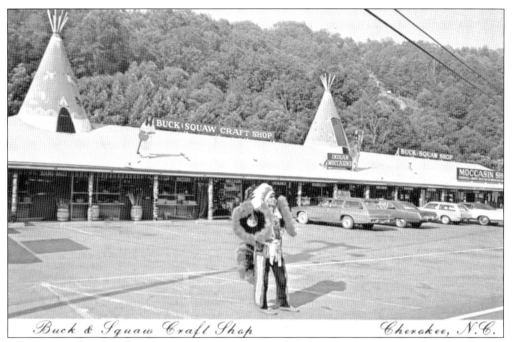

**BUCK AND SQUAW CRAFT SHOP, CHEROKEE, N.C.** The Buck and Squaw Craft Shop is located in Main Street in Cherokee. They specialize in Native American moccasins and are known as the largest Cherokee craft shop. This chrome-era postcard was taken in the heyday of Cherokee and the western movie phenomena. Children loved the tomahawk and drum toys produced by the Cherokee. (Courtesy of Advertising Unlimited.)

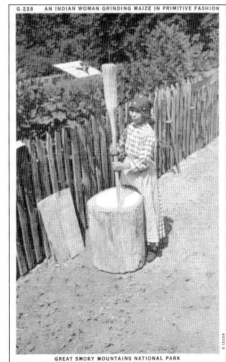

**AN INDIAN WOMAN GRINDING MAIZE.** Maize is a staple in the Cherokee diet. This linen-era postcard depicts the hard work of grinding maize. It is a type of corn and is ground into cornmeal to be used for bread and other dishes. (Courtesy of Asheville Post Card Company.)

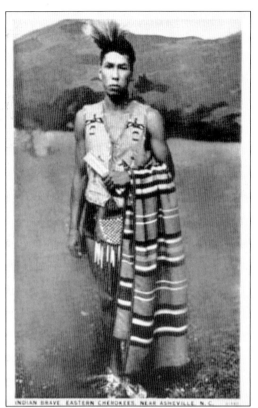

**INDIAN BRAVE OF THE EASTERN CHEROKEE.** This Cherokee brave stands handsome and tall holding a Cherokee hand-woven blanket and handmade bead bag in this black-and-white-era postcard. They are two of the crafts sold in the Cherokee craft shops. Today, preserving their heritage, the Oconaluftee Village citizens teach children and adults about their past. (Courtesy of W. M. Cline.)

**BEAUTIFUL DESIGNS ARE ORIGINATED BY CHEROKEE WOMEN IN THEIR BEADWORK AT OCONALUFTEE INDIAN VILLAGE, CHEROKEE, N.C.** In the Oconaluftee Indian Village, these Cherokee women show the artistic talent of their people. Notice the baskets in their laps that are full of beads and divided by color. Behind their heads hang exquisite belts that are completed with the beadwork in this chrome-era postcard. (Courtesy of W. M. Cline.)

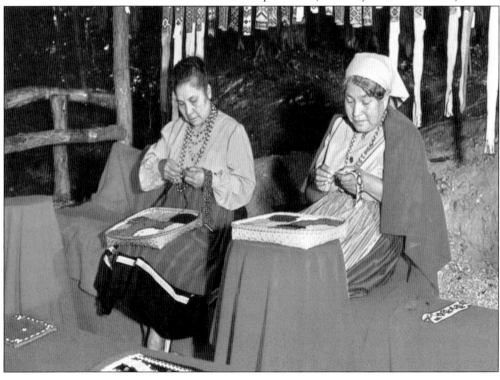

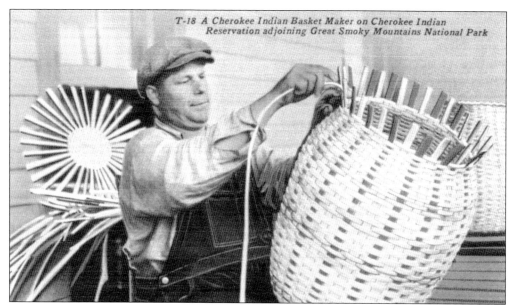

A CHEROKEE INDIAN BASKET MAKER ON THE CHEROKEE INDIAN RESERVATION. This very detailed linen-era postcard depicts the ancient art of basket making. The strips of wood are a natural color with red being alternated throughout the project. One of the most desired trade objects, the Cherokee baskets have a uniqueness of their own. Skill and time go into each. (Courtesy of Asheville Post Card Company.)

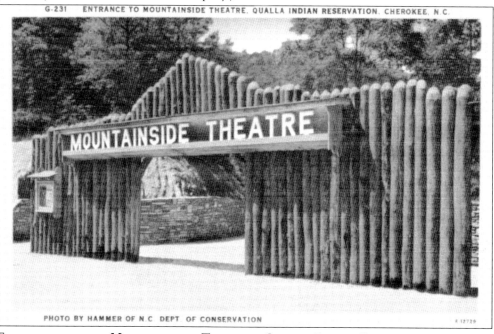

ENTRANCE TO THE MOUNTAINSIDE THEATRE, QUALLA INDIAN RESERVATION. Opening on July 1, 1950, *Unto These Hills* has become the longest-running outdoor drama performed in America with over 5 million visitors viewing this awesome show from its start. This play tells the story of the Cherokee from their initial meeting with Hernando DeSoto until 1838 when they leave the Smoky Mountains on the Trail of Tears. (Courtesy of Asheville Post Card Company.)

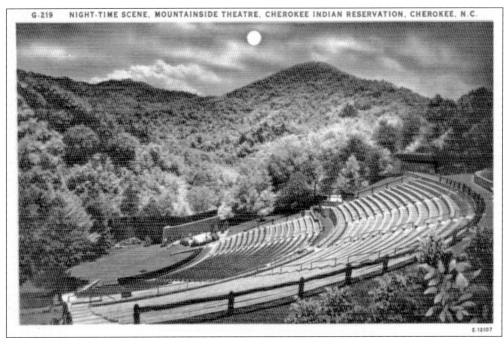

**NIGHT-TIME SCENE, MOUNTAINSIDE THEATRE.** Acoustically positioned, the amphitheater has the most magnificent sound for an outdoor theatre as shown in this linen-era postcard. One of the most compelling outdoor dramas, *Unto These Hills*, tells the tragic story of how the Cherokee ancestors were forcefully driven out of the Great Smoky Mountains and marched 1,200 miles to Oklahoma. (Courtesy of Asheville Post Card Company.)

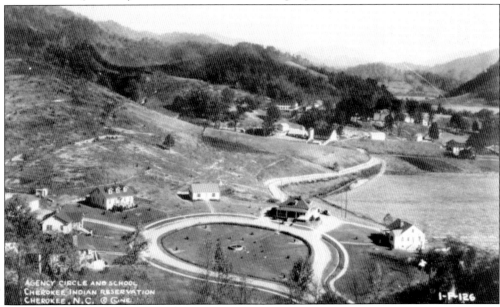

**BUREAU OF INDIAN AFFAIRS AGENCY CIRCLE AND SCHOOL, CHEROKEE INDIAN RESERVATION, N.C.** This photographic postcard taken in the 1930s depicts the homes of the Bureau of Indian Affairs leader and the Cherokee School. Today all that is left is the circle drive and the tall hemlocks, which are very small in this black-and-white photo postcard. (Courtesy of W. M. Cline.)

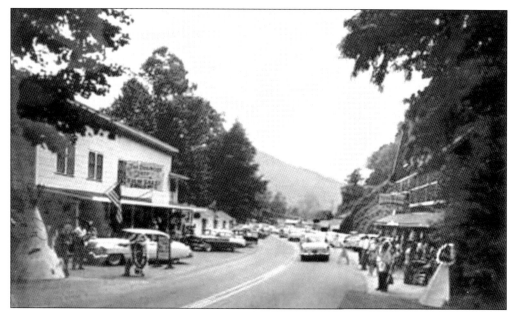

MAIN STREET, CHEROKEE, NORTH CAROLINA. The Cherokee Indian Reservation began selling craft items to the public before the Blue Ridge Parkway was completed. On the right in this 1950s chrome-era postcard view is the Totem Pole gift shop. With the production of western movies for television, Cherokee capitalized on the popular cowboy and Native American themes. (Courtesy of W. M. Cline.)

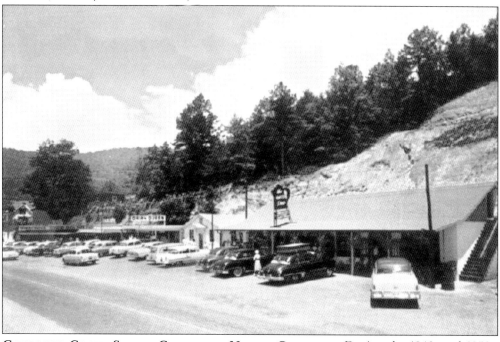

CHEROKEE CRAFT SHOPS, CHEROKEE, NORTH CAROLINA. During the 1940s and 1950s, visitors flocked to the Cherokee Indian Reservation. An increase in traveling after World War II increased exponentially the economy of the reservation. This chrome-era postcard shows shops and a very early Dairy Queen along with the old cars. (Courtesy of W. M. Cline.)

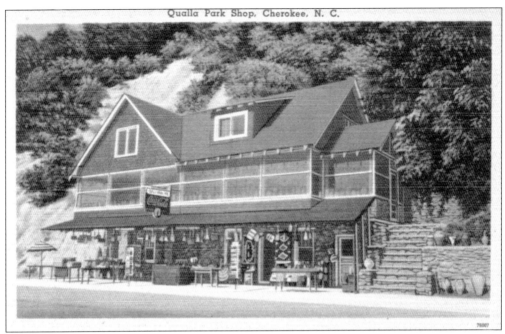

**TOTEM POLE, QUALLA PARK SHOP, CHEROKEE, N.C.** Built in the late 1920s, the Totem Pole, shown in this linen-era postcard, is one of the oldest shops in Cherokee. Irene Robertson, proprietor and manager, was one of the first operators of the Totem Pole Gift Shop in Cherokee. This unique shop is located on State Highway 107 in the Cherokee. (Courtesy of W. M. Cline.)

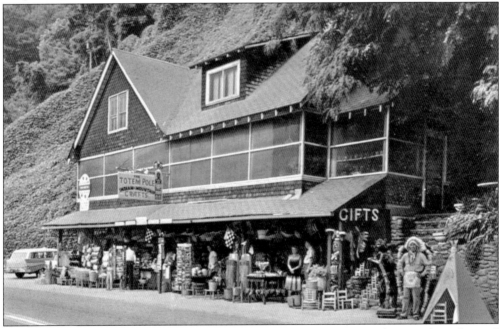

**TOTEM POLE, CHEROKEE, N.C.** When this snapshot of the Totem Pole was taken, the road had been renumbered to 441. Martha Feltus Tate was the owner when this chrome-era postcard was taken. This postcard of the Totem Pole shows the ability of W. M. Cline to change his production process from the linen type to the chrome type. (Courtesy of W. M. Cline.)

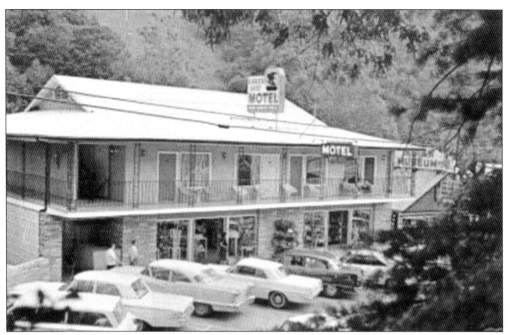

**EAGLE'S NEST MOTEL AND GIFT SHOP.** Hailed as one of the oldest motels in Cherokee, North Carolina, the Chief Motel sits atop a wonderful gift shop.

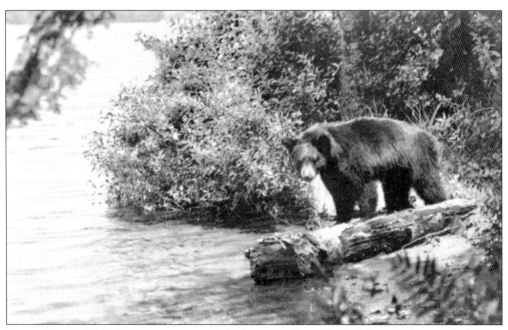

**BLACK BEAR.** This chrome-era postcard depicts a yearling cub black bear in characteristic pose. This is a sight frequently glimpsed by tourists and sportsmen throughout the eastern United States. Researchers studying hibernating bears have found that instead of disposing of their metabolic waste, bears recycle it. For example, denning bears normally turn potentially toxic nitrogen compounds into protein. (Courtesy of Anthony Marie Jr.)

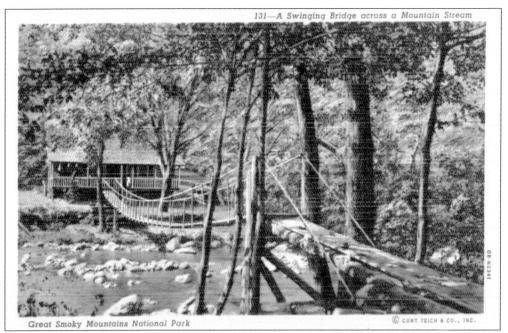

**A SWINGING BRIDGE ACROSS A MOUNTAIN STREAM.** One of the most memorable scenes in Cherokee is the swinging bridge that connects the visitors to the craft shops. In this linen-era postcard, the swinging bridge goes to a wonderful log cabin home. Old fashioned log homes were usually built near a stream. (Courtesy of Curt Teich and Company, Inc.)

**SOCO CRAFTS AND MAGGIE VALLEY, NORTH CAROLINA.** This black-and-white-era postcard shows the Soco Craft Shop in its early days of business on the busy road of 19 between the Cherokee Indian Reservation and Maggie Valley. One of the most frequented gift shops, it still operates and looks pretty much the same. Today they have a tower for photographers to climb. (Courtesy of W. M. Cline.)

# Six

# Gatlinburg and Pigeon Forge, Tennessee

*Season to Season, Gatlinburg and Pigeon Forge is the perfect combination of relaxation and recreation, of natural beauty and man-made fun, of the breathtaking mountains and unforgettable good times.*
—Gatlinburg Chamber of Commerce

Gatlinburg (formerly known as White Oak Flats) and Pigeon Forge are located in Sevier County, Tennessee. Sevier County is one of the larger counties in the state of Tennessee and is bordered by North Carolina.

In this chapter, the reader will see many linen-era and chrome-era postcards produced on Gatlinburg and Pigeon Forge, Tennessee. They will see the commercial as well as the historical sides of Sevier County.

During the 19th century, the first settlers in the valley of the West Fork of the Little Pigeon River and its tributaries were the Oglesby (Ogle) family from South Carolina. Widow Martha Jane Huskey Ogle brought her seven children to the area. Her cabin can still be seen today at the Arrowmont School of Arts and Crafts.

Timbering began replacing sustenance farming as the primary economy base in the early 1900s. Gatlinburg's first hotel was built to accommodate traveling lumber buyers. With the coming of the national park and tourism in the 1930s, the economy of the area began to pick up.

Pigeon Forge is a unique town. Pioneer Isaac Love established an iron forge there in 1820. His son, William, built a tub mill 10 years later. The Old Mill, now a National Historic Site, remains operational.

MISS BISHOP'S GUEST COTTAGE. This rare sketch-type postcard was drawn of Miss Bishop's guesthouse. It was located on the crest of Burg Hill on the Roaring Fork Road in Gatlinburg, Tennessee, sometime in the 1930s. Sketching scenes was a favorite artistic venue in the late 19th century. Sketching is inexpensive, and almost anyone can practice with a pencil and piece of paper.

NEW RIVERSIDE HOTEL, GATLINBURG, TENNESSEE. Riverside Hotel is one of the oldest hotels in Gatlinburg. After the construction of the Blue Ridge Parkway and the Great Smoky Mountains National Park, many of the area residents went into the hospitality business by building facilities like the one here. This is a black-and-white-era postcard. Resort towns sprang up all along the scenic highway. (Courtesy of W. M. Cline.)

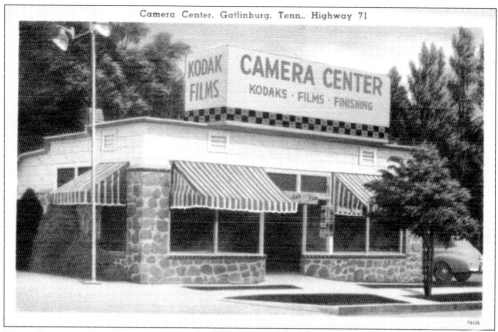

THE CAMERA CENTER, GATLINBURG, TENN., HIGHWAY 71. The Camera Shop boasted developing film within six hours on this linen-era postcard at a time when film developing took a week. Today the Camera Shop is part of a strip complex near the entrance to the Great Smoky Mountains. (Courtesy of Standard Souvenirs and Novelties, Inc.)

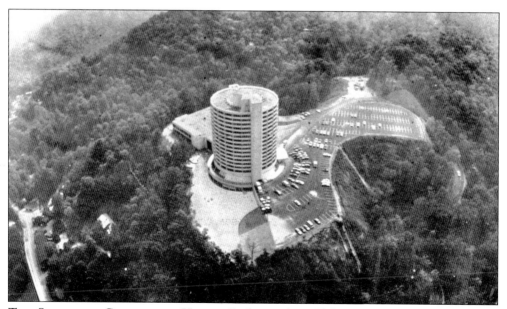

THE SHERATON-GATLINBURG HOTEL. Built on a beautiful mountain peak, the Sheraton-Gatlinburg has become a landmark of this busy town. This black-and-white chrome-era postcard boasts 315 luxurious rooms with 315 balconies with 315 beautiful views of the Smokies. A long, winding drive leads to the grand hotel.

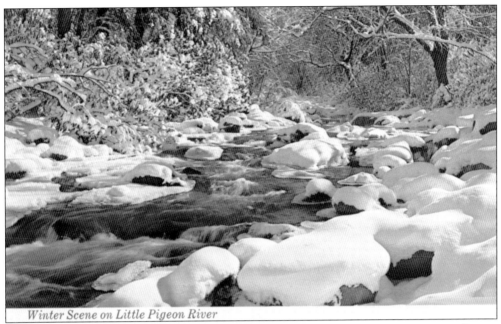

**WINTER SCENE ON LITTLE PIGEON RIVER–GREAT SMOKY MOUNTAINS NATIONAL PARK.** W. M. Cline took this snow-capped scene on the Little Pigeon River sometime in the late 1960s. Snow scenes are rare because of the difficulty in getting to the locations. Once taken, the scenes are priceless. Snow creates a winter wonderland with a totally different look from spring, summer, and fall. (Courtesy of W. M. Cline.)

**BROOKSIDE MOTEL AND RANCH HOUSE, GATLINBURG, TENN.** One postcard observer said, "I stayed here!" This room is similar to many other rooms found within the Gatlinburg and Pigeon Forge area. The Brookside Motel is located on Roaring Fork Road, Highway 73, in Gatlinburg. A mountain stream, spacious grounds, heated swimming pool, and kitchenettes are claimed on this chrome-era postcard. (Courtesy of W. M. Cline.)

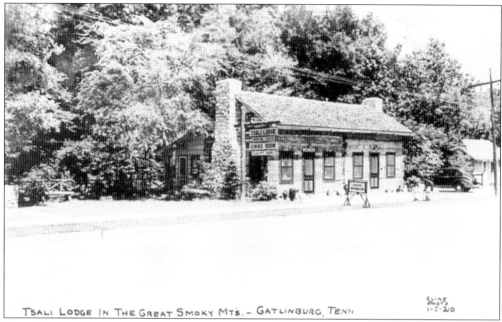

**TSALI LODGE IN THE GREAT SMOKY MTNS.–GATLINBURG, TENN.** Taken sometime in the 1930s, this rare, vintage black-and-white-era postcard of Tsali's Lodge shows a dining room experience unto its own. This was an early restaurant for the weary traveler. "Tsali" means "Charlie" in the Cherokee native tongue. (Courtesy of W. M. Cline.)

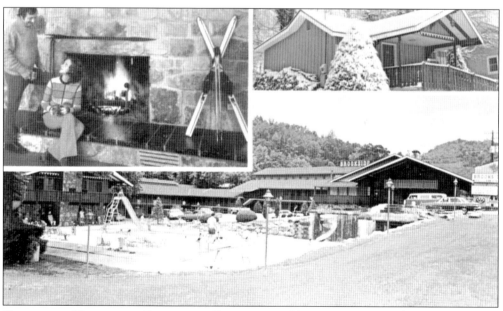

**BROOKSIDE MOTEL AND COTTAGES, GATLINBURG, TENNESSEE.** Located on a private drive near a mountain stream, Brookside Motel has been a family favorite for many years. It offers a swimming pool, picnic area, 100 rooms, and 20 cottages. This chrome-era postcard is typical of the 1960s and early 1970s motel advertising. (Courtesy of C. Hugh Edwards.)

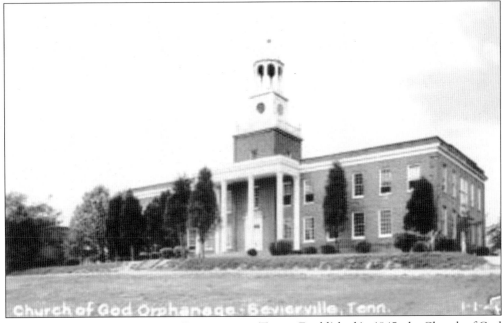

CHURCH OF GOD ORPHANAGE, SEVIERVILLE, TENN. Established in 1945, the Church of God Orphanage housed the children and provided a school. The facility was moved from Cleveland, Tennessee, to Sevierville because this facility had more room to grow. The Church of God roots began in Cherokee County, North Carolina, and moved across the mountains to Cleveland, Tennessee. (Courtesy of W. M. Cline.)

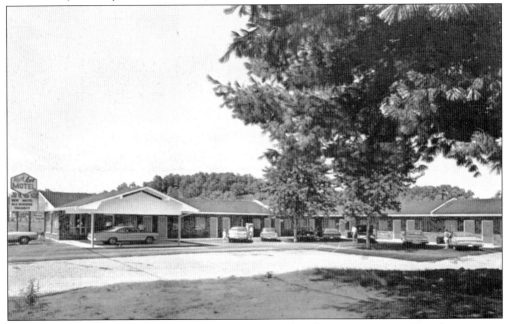

MARK ANN MOTEL, SEVIERVILLE, TENN. Sevierville is host to many motels and restaurants like the Mark Ann Motel. This is a great example of a locally owned and operated facility for travelers. This 1960s chrome-era postcard says that they were air-conditioned, had wall-to-wall carpet, and a television in 31 units. (Courtesy of W. M. Cline.)

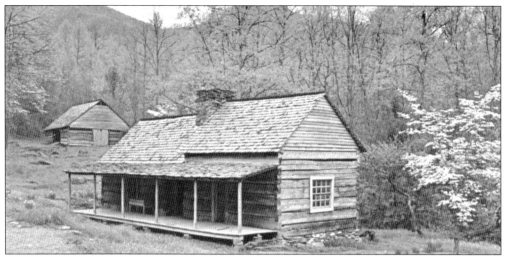

**JUNGLEBROOK–RESTORED MOUNTAIN FARMSTEAD–GREAT SMOKY MOUNTAINS.** Located near Gatlinburg on the Cherokee Orchard–Roaring Fork Loop Road, this old farmstead was restored by the National Park Service as part of a program to preserve the way of life of the old settlers of the mountain region. This homestead is located on a rocky hillside slope with a mountain stream running nearby. (Courtesy of W. M. Cline.)

Rebel Railroad actually traces its roots back to 1961 when it first opened on the site that, over time, has expanded and grown into Dollywood. The Robbins brothers from North Carolina operated a small-scale attraction that featured a coal-fired steam train named *Klondike Katie*, a general store, a blacksmith shop, and a saloon for visitors to enjoy. In 1970, Rebel Railroad underwent a change in ownership and name when it was purchased by Art Modell, then owner of the NFL's Cleveland Browns. Under new ownership, Rebel Railroad was renamed Goldrush Junction and was touted as "Tennessee's Million Dollar Fun Attraction." In 1976, the Herschend family entertainment company bought Gold Rush Junction Park in Pigeon Forge, Tennessee. They spent about $1 million on improvements and reopened the park as Silver Dollar City, Tennessee. The Herschends formed a partnership with country music legend Dolly Parton in 1986. Silver Dollar City was renamed Dollywood. (Courtesy of W. M. Cline.)

# BIBLIOGRAPHY

Badger, Anthony J. *North Carolina and the New Deal*. Raleigh, NC : North Carolina Department of Cultural Resources, Division of Archives and History, 1981.

BeCraft, Patricia A., Janet S. Johnson, Ann S. Laing, Adelaide Smith, Barbara L. Umberger, J. Elton Walters. *Greetings from Wythe County, Virginia*. Wytheville, VA: Wythe County Historical Society, 2004.

Blouin, Nicole, Steve Bordonaro, and Marilou Wier Bordonaro. *Waterfalls of the Blue Ridge: A Hiking Guide to the Cascades of the Blue Ridge Mountains*, Third Ed. Birmingham, AL: Menasha Ridge Press, 1994, 1996, 2003.

Conn, Charles W. *Like A Mighty Army: Moves the Church of God*. Cleveland, TN: Church of God Publishing House, 1955.

Durant, John and Alice. *The Presidents of the United States*. New York, NY: A. S. Barnes and Co., Inc., 1974.

http://en.wikipedia.org/wiki/Appalachian_Mountains

http://en.wikipedia.org/wiki/Blue_Ridge_Parkway

http://gorp.away.com

http://www.cr.nps.gov

http://www.mimslyninn.com/history.htm

http://www.mountainchalets.com/gatlinburg.htm

http://www.nps.gov/blri/culture.htm

http://www.nps.gov/shen/home.htm

http://www.visitsmokies.org

Jolley, Harley E. *The Blue Ridge Parkway*. Knoxville, TN: University of Tennessee Press, 1969.

———. *The CCC in the Smokies*. Gatlinburg, TN: Great Smoky Mountain Association, 2001.

"Kituwah: First Village of the Cherokee." *Mountain Traveler* 23 (Spring/Summer 2005).

McClintock, John. *A Short History of the Postcard in the United States*. Manassas, VA: International Federation of Postcard Dealers, 2005.

Rawls, Molly Grogan. *Greetings from Winston-Salem, NC*. Charleston, SC: Arcadia Publishing, 2004.

Rozema, Vicki. *Footsteps of the Cherokees: A Guide to the Eastern Homelands of the Cherokee Nation*. Winston-Salem, NC: John F. Blair Publishing, 1995.

Sigalas, Mike and Jeff Bradley. *Moon Handbooks: Smoky Mountains*. Emeryville, CA: Avalon Travel Publishing, 2002.

Smith, Karen Cecil. *Orlean Puckett: The Life of a Mountain Midwife*. Boone, NC: Parkway Publishers, 2004.

Time Life Books. *This Fabulous Century: 1930–1940*. USA: Time-Life Books, 1988.

# INDEX

Allen Clan, 35, 36
Alum Cave, 93
Asheville, 60
Balsam Mountain, 55
basket making, 108
bead work, 110
Bedford, Virginia, 19
Big Creek Road, 94
Biltmore Estate, 62
black bear, 84, 99, 106, 117
Blowing Rock, 40–43, 60
Blue Sea Falls, 48
blue sky era, 10
Breneman, David, 71
Brookside Motel, 122, 123
Buck and Squaw Gift Shop, 111
Buck Creek Gap, 49
Buffalo Mountain, 28
Bullhead, 94
Burg Hill, 121
Burnsville, North Carolina, 62
cabin, 18, 22, 32, 33, 40, 54, 95, 98
Cable, John P., 100
Cades Cove, 100, 101
Camera Shop, 122
Camp David, 63
Camp Hoover, 63
Canton, North Carolina, 57
Carroll County, Virginia, 26, 31, 35, 36
Cataloochee, 94
Cherokee Indian Reservation, 109–118
Cherokee Orchard, 125
Chimney Rock, 51–54
Chimney Tops, 79, 80, 81, 102
chrome era, 10
Church of God, 124
Civil War, 9, 30
Civilian Conservation Corps, 11, 46, 75, 79, 83
Clifton Forge, 19
Clingman, Thomas L., 90, 91
Clingman's Dome, 87–92, 97
cone, 43, 45
*Dan River Queen*, 24

Davis, Anne May, 75
Davis, Willis P., 75
Deep Creek Falls, 97
delotigoist, 9
Desoto, 113
divided back, 9
Dollywood, 125
Doughton Park, 38
Eagle's Nest Motel, 117
Elkmont, Tennessee, 60, 101
Fairfax, Lord, 15
Fancy Gap, Virginia, 25–27
fence, 32
Floyd County, Virginia, 24, 37
FRIENDS, 7, 8
Galax, Virginia, 4
Gatlinburg, Tennessee, 80, 119, 120–123
Gold Rush Junction, 125
golden era, 9
Goundhog Mountain, 31, 32
Great Smoky Mountains, 75–106
Gregory Bald, 95, 96
Hickory Nut Falls, 54
Hillsville, Virginia, 25, 35, 36
Hoar Frost, 102
Hoover, Pres. Herbert, 63
Humpback Rocks, 32
Hyatt, Col., 37
Indian Creek Falls, 97
Jefferson, Thomas, 15, 18, 30
Jolley, Harley, 7, 11, 63
Junglebrook, 125
Lace Falls, 20
Lake View Motel, 37
Le Conte Creek, 104
linen era, 10
Linville Falls, 44
Linville Mountain, 46
Little Pigeon River, 119, 122
Little River, 105
Little Switzerland, 5, 46
Looking Glass Rock, 50
Loop-Over, 78, 81, 83
Lost River, 16

Luray, 71
Mabry Mill, 21, 22
Maggie Valley, 118
Mark Ann Motel, 124
Mayberry Trading Post, 23
Meadows of Dan, 21
Mile High Overlook, 106, 109
Mimslyn, 65
Mitchell, Elisha, 47, 48
Mount Le Conte, 93, 96
Mount Mitchell, 47, 48, 90
Mount Sterling, 94
Mountain Top Motel, 26, 27
Museum of North Carolina Minerals, 51
Natural Bridge, 14–18
New Deal, 75, 82
New Riverside Hotel, 120
Newfound Gap, 75, 77, 80–85
Oconaluftee Gorge, 88
Oconaluftee Village, 112
Peaks of Otter, 19, 33
Phillips, C. D., 25, 26
Pigeon Forge, 119, 124, 125
Pilot Mountain, 28, 30
Pinnacle Mountain, 58
pioneer era, 9
Point Lookout, 61
Pollock, George Freeman, 73
pottery, 110
Pratt, Joseph Hyde, 37
Qualla, 113
Rainbow Falls, 104
Rapidan River, 63
real-photo, 10
Rebel Railroad, 125
Rhododendron, 12, 38, 97
Roanoke, Virginia, 20, 34
Roaring Fork Road, 120
Robinson, Claude, 28
Rockbridge County, Virginia, 17
Rockefeller, John D., 49
Rockefeller, Laura Spelman, 86
Rumple, Dr. Jethro, 42
Seiverville, 124
Sharp Top, 19
Shenandoah National Park, 63–74
Sheraton-Gatlinburg, 121
Singing Tower, 71
Skyland, 73
Skyline Drive, 63–74
Smokemont, 99
snow, 73, 76, 85, 92, 102, 105, 122

Soco Crafts, 118
Southern Railway, 55
Stony Man Mountain, 70, 72
Stuart, Virginia, 24
Sugarlands, 77
Swift Run Crossroads, 66
Swinging Bridge, 56, 118
teepee, 119
Tellico River, 102
The Sinks, 103
Thunderhead Mountain, 98
Timber Hollow, 70
tobacco, 39
totem pole, 116
Townsend, 105
Tsali Lodge, 123
tunnel, 65, 68, 82, 83
Valley Motel, 13
Vanderbilt, 62
Warrenton, Virginia, 70
Washington, George, 15
Waynesboro, Virginia, 19, 32, 63, 74
White Oak Canyon, 73
Whiteside Mountain, 50
Yancey County, North Carolina, 57